Art for Heart

for

Heart

Remembering
9/11

Art for Heart is dedicated to those lost in the terrorist attacks on February 26, 1993, and September 11, 2001

This book is made possible through a gift from Emigrant Bank and the Milstein Family. Proceeds go to the National September 11 Memorial & Museum in New York City.

Front cover: *Squeezing of America*, 2001, painting by Katie Profusek, courtesy of the NYU Child Study Center.
Back cover: *Having Each Other*, 2001, painting by Andrew Stern, courtesy of the NYU Child Study Center.

Art for *for* Heart
Remembering
9/11

ASSOULINE

TEARS welled up just thinking about the THOUSANDS of people who lost their lives HELPING out or just being at their jobs!

Ella
NYU Child Study Center

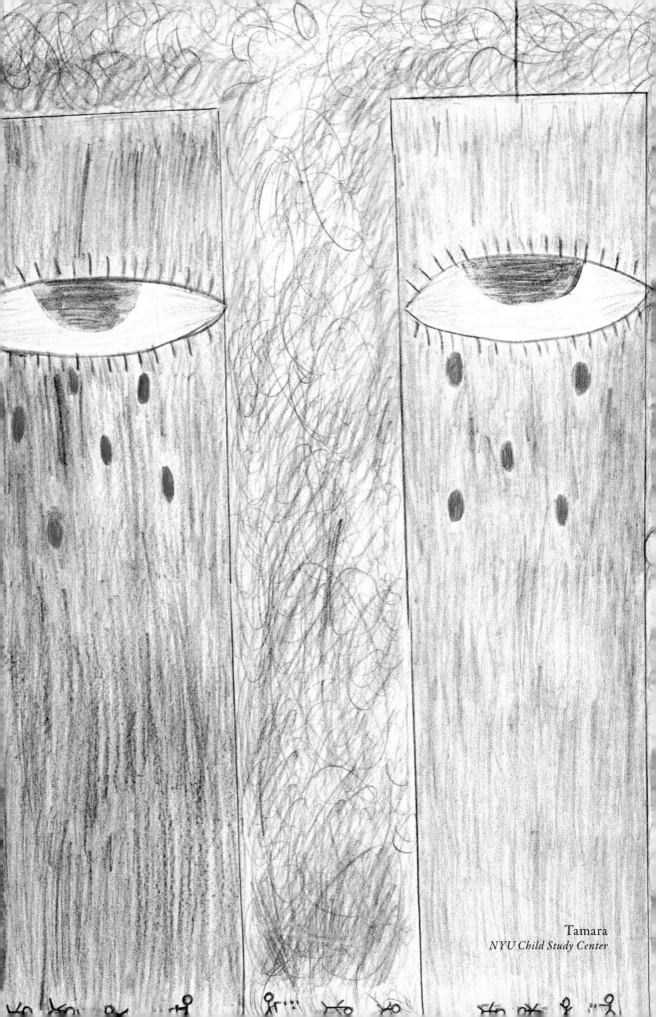

Tamara
NYU Child Study Center

It started like any other day. Wake up. Walk the dog. Make scrambled eggs. Change a diaper. Catch a cartoon before school. Drive to work. Fall asleep in science class.

It was the morning of September 11, 2001, in America, and the world changed forever.

That morning, in an instant our sense of safety and confidence was rocked by uncertainty, fear, and helplessness. Through the notes left at firehouses, on billboards, in school hallways, and in comfort zones, such as the New York University Child Study Center, and on the World Trade Center's steel beams featuring "Notes of Hope" that crisscrossed the country in 2006, we hear from the children who will never forget the images of planes piercing through the World Trade Center and the Pentagon, and into the ground in Shanksville, Pennsylvania. Some of them thought they were watching a bad sci-fi movie. Some remember that we prayed. Some remember that their teacher fainted. Another teacher cried. Those were their first memories.

All of us were affected by the events of 9/11, but it was the youngest generation who was affected most of all. Children who had never experienced violence or hatred. Children who lost a parent, grandparent, or other family members that morning. Their innocence dissolved as easily as the two jetliners that sliced into the Twin Towers.

The children of 9/11 provide a unique perspective—one that inspires us today and the generations yet to come.

One of those children was a sixteen-year-old girl who lost her stepfather in the North Tower. As she mourned her loss, she decided that all of the other children who suffered a loss from this tragedy needed a way to express their emotions—their pain, but also their hope. She wanted these children to mourn those who died, but also to celebrate life.

The sixteen-year-old girl, who is now a paramedic, created a project called "Art for Heart," with the help of New York City's 92nd Street Y and the Lower Manhattan Development Corporation. In 2003, 457 children who lost parents on September 11th came together in community centers in New York City, New Jersey, and Long Island to express themselves on canvas.

The results were astonishing. Their artwork traveled the country, including an exhibition at New York City's American Museum of Natural History, and on military bases around the world. This book marks the first time their art has been shared with a wider audience.

What these children communicated through their art and words is heartbreaking, but much of it is also heartwarming. These works are reminders of how connected we can be—as individuals, as a nation, as a global community—and that goodness can shine through even in the darkest hour.

With the help of these indelible memories, we can find that again. And, once again, reunite.

Christy Ferer

Board Member, The National September 11 Memorial & Museum, and the widow of Neil Levin, lost in the 9/11 attacks

REME

DAY
I will
NEVER
forget.
It was
HORRIBLE
and

BEAUTIFUL
at the
same time
because
EVERYONE
came
TOGETHER.

Elizabeth
NYU Child Study Center

Emma
NYU Child Study Center

The innocence that was so profoundly disrupted on 9/11 is perhaps nowhere better demonstrated than in the words and drawings of thousands of children in the days and weeks following the attacks. In their straightforward depiction of the events, these works are testaments to the very human instinct to bear witness, provide comfort, and attempt to make sense out of the unthinkable.

With a mission to commemorate, educate, and inspire, the National September 11 Memorial and Museum (the 9/11 Memorial) will build upon the messages of remembrance and gratitude communicated by these youngest witnesses to history. With a decade behind us, the obligation to remember becomes even greater: to learn about and teach not only what happened on 9/11, but also the countless expressions of compassion, service, and dedication demonstrated in the aftermath of the attacks. In many respects, the "9/12" story is as important as the 9/11 one: in the demonstration of unity of purpose, generosity of spirit, and the simple commitment to assist others before ourselves, we affirmed that the human capacity for empathy and compassion can indeed triumph over the human capability to commit acts of evil.

The 9/11 Memorial opens in conjunction with the observance of the tenth anniversary of the attacks. The Memorial Museum will follow on the eleventh anniversary, in 2012. A significant body of material in the museum's permanent collection is comprised of children's expressions of their experiences: materials preserved from schools and firehouses; art created by grieving children in therapeutic programs; postcards, drawings, and letters sent to war memorials in Europe by students abroad, unsure of where else to mail their messages of hope and solidarity. Many of the images in this book have been drawn from the New York University Child Study Center archive, a collection donated to the Memorial Museum in 2010.

In sharing this material, we provide a preview of the rich resources that will be presented at the 9/11 Memorial Museum. More importantly, we allow these children, many of them now entering adulthood and inheriting a world of challenges, to remind us of what really matters: that an act of terrorism—anywhere—is an assault on all of us; and that when we hurt, we can come together using a variety of manners and media for expression and affirm the power that arises when we connect to one another.

Alice M. Greenwald

Director, 9/11 Memorial Museum

I am grateful to live in a land where we share each other's joy and sorrow, pain and healing.

I AM THANKFUL TO BE AN AMERICAN. MAY GOD BLESS AMERICA.

Joyce
NYU Child Study Center

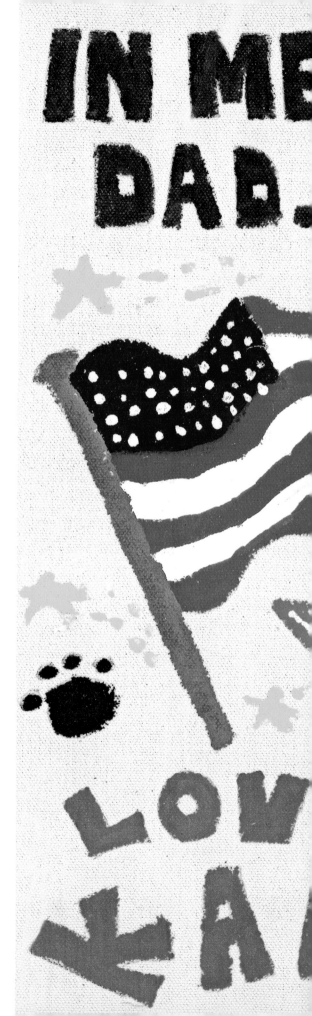

MORY OF MY
.STUART
S. LOUIS

A

Art for Heart

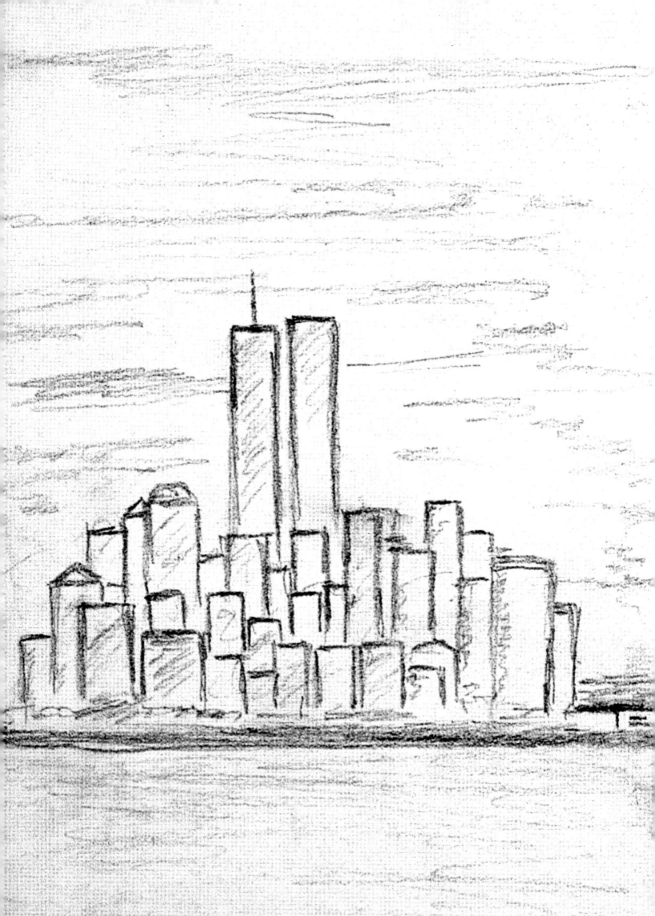

Master John
NYU Child Study Center

Before
September 11, 2001

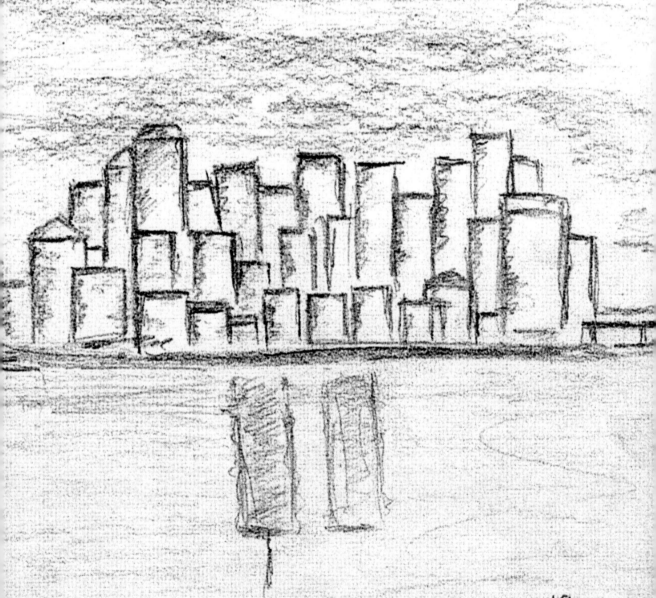

by M. S. Horrattin After
 September 11, 20

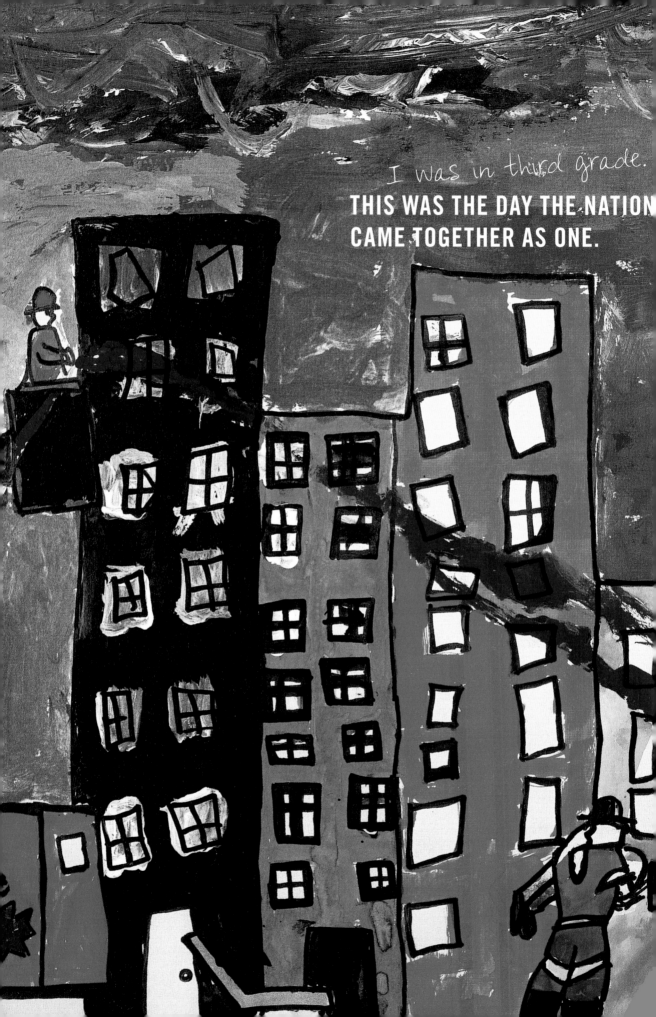

I was in third grade.
THIS WAS THE DAY THE NATION
CAME TOGETHER AS ONE.

IT WAS THE DAY MANY HEROES WERE CROWNED TO SAVE OTHER PEOPLE.

Cory
Notes of Hope

Jazmyne, Jorge, Justin, and Tynell
NYU Child Study Center

I was in 8th grade science class. My dad was called that day because he was a retired Marine. I am going to be a politician to make this world SAFER.

Braquet
Notes of Hope

18

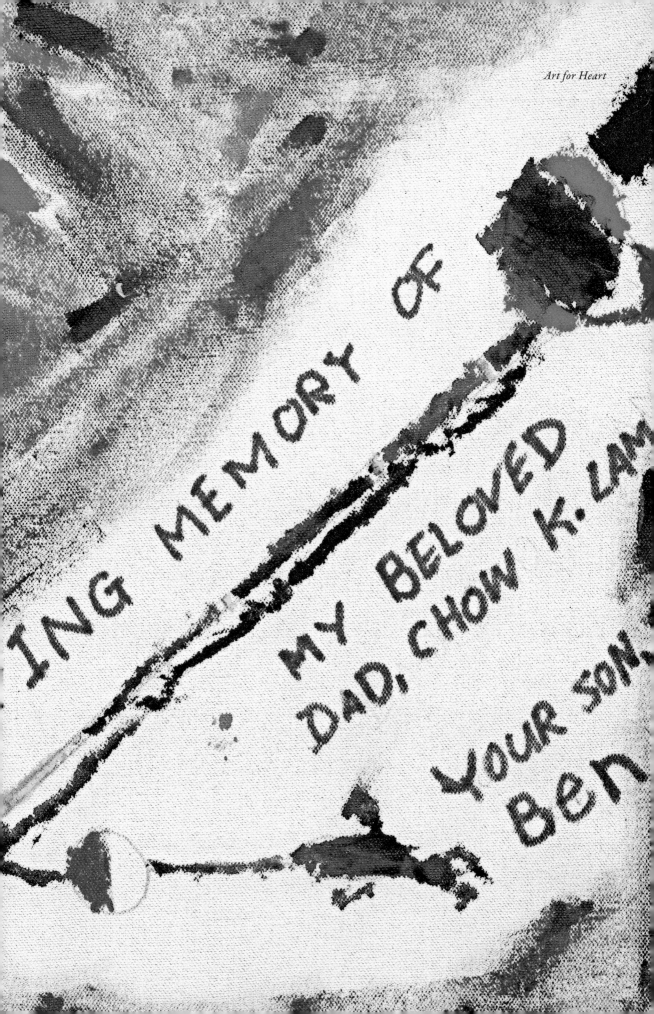

ING MEMORY OF MY BELOVED DAD, CHOW K. LAM YOUR SON, BEN

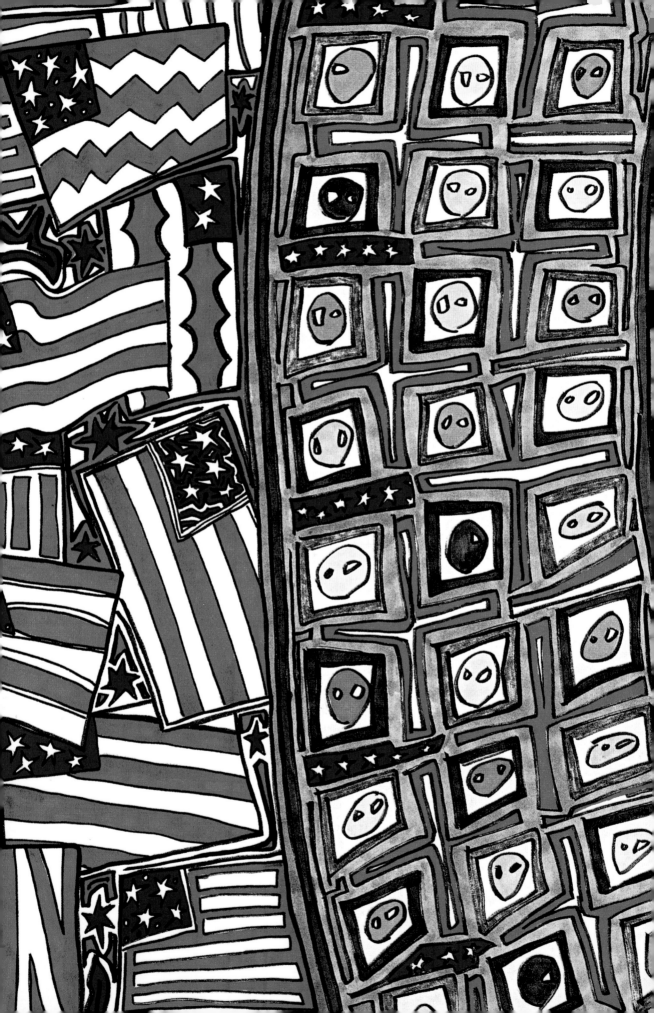

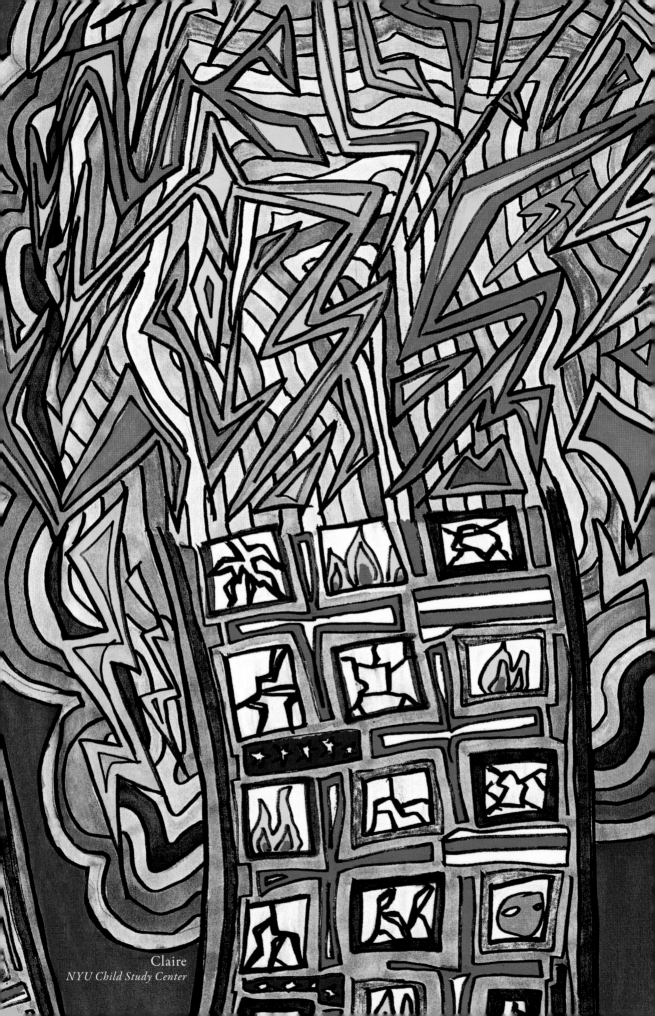

Claire
NYU Child Study Center

Let us always remember how our country came together. For once in my generation

Trena
Notes of Hope

Art for Heart

we united as one in resilience, perseverance, and prayer for one another.

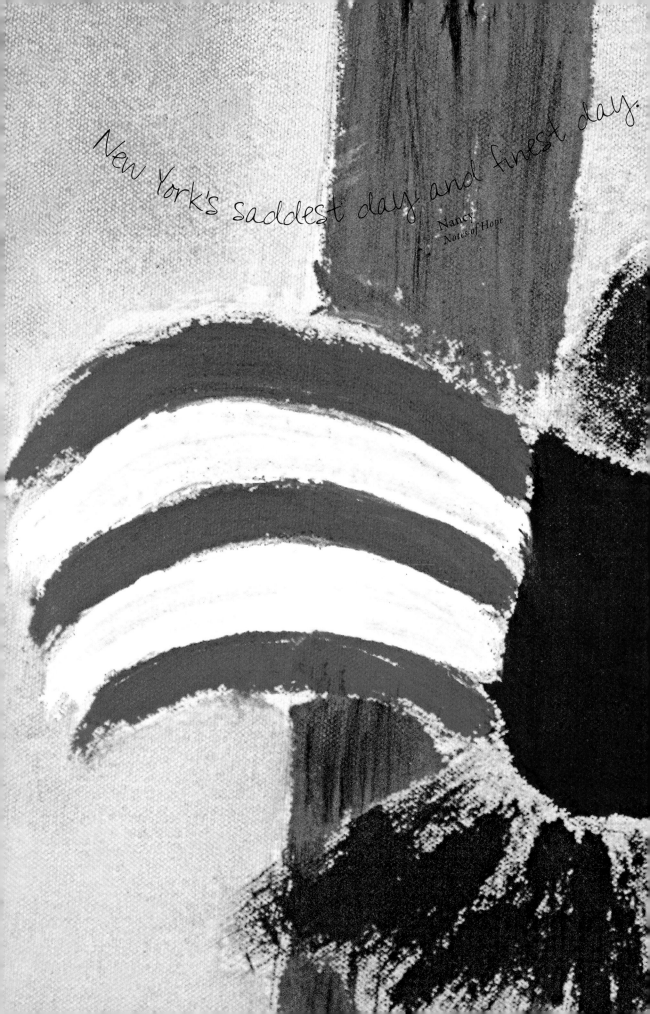

New York's saddest day, and finest day.

Nancy
Notes of Hope

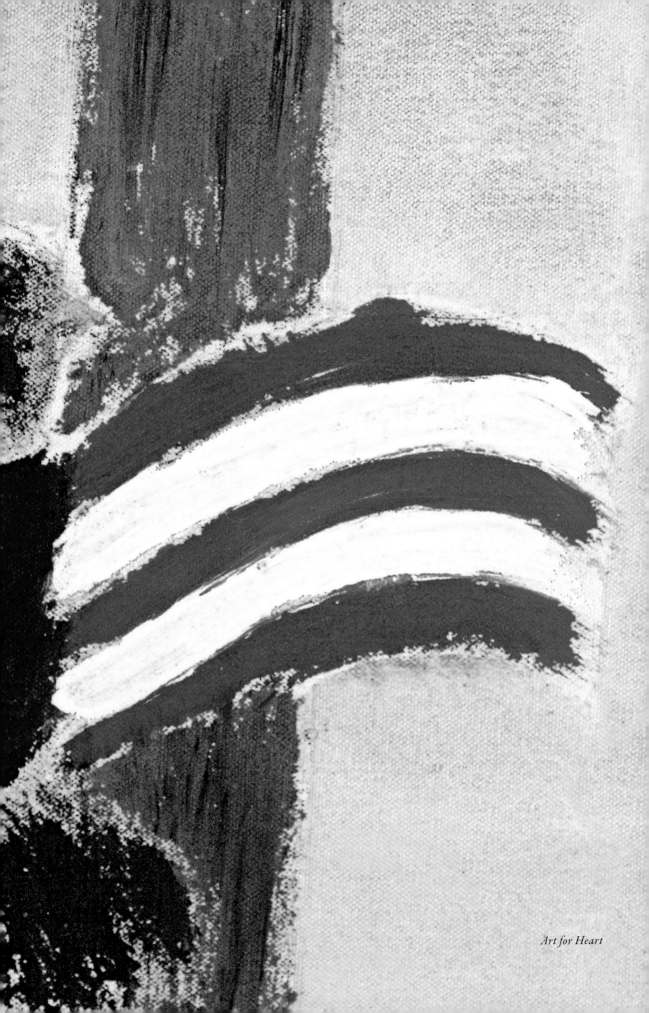

Art for Heart

NO TOL

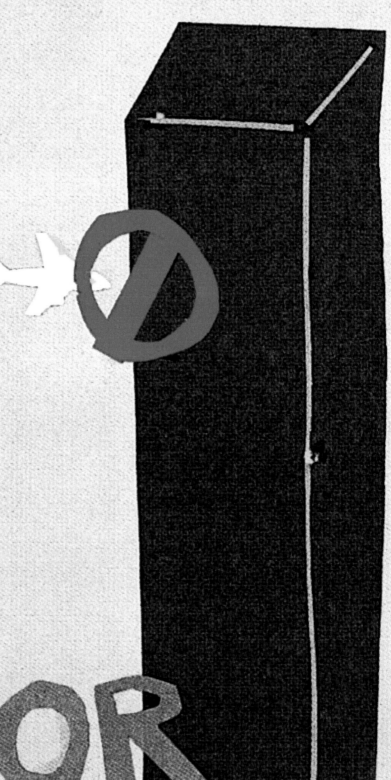

FOR

Brian
NYU Child
Study Center

I WAS IN FIRST GRADE.

IT WAS MY GENERATION'S

PEARL HARBOR.

Aaron
Notes of Hope

Charles
NYU Child Study Center

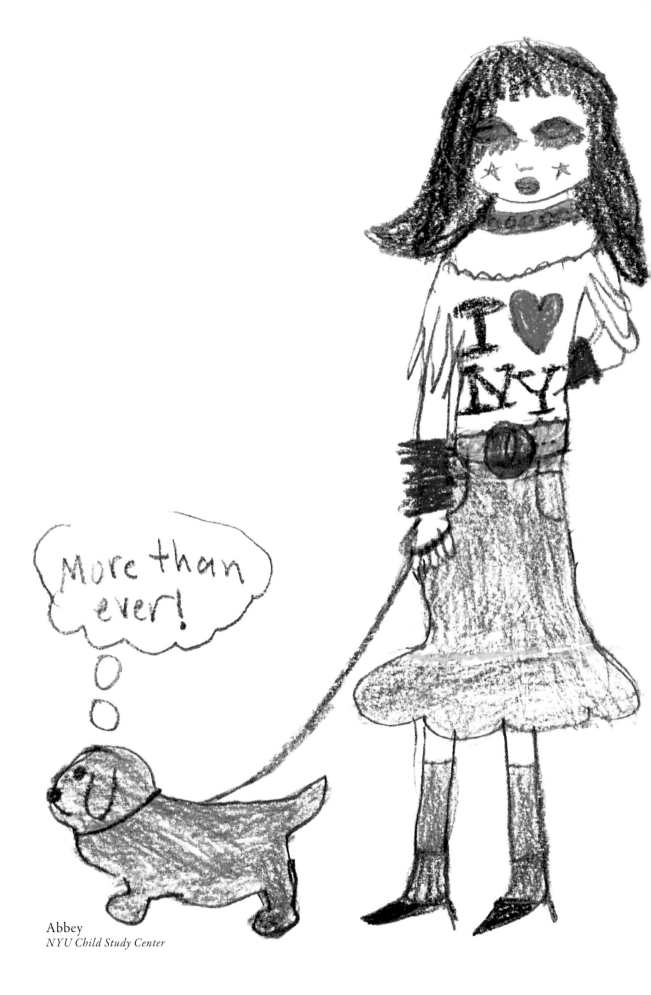

Abbey
NYU Child Study Center

'I WAS IN 4TH GRADE MAKING CHOCOLATE CASTLES FOR CHARLIE AND THE CHOCOLATE FACTORY WHEN WE HEARD THE NEWS.

AS A KID, I DIDN'T QUITE UNDERSTAND WHAT WAS HAPPENING, BUT WHEN I SAW THE IMAGES

FROM NY, I CRIED.

Emma
Notes
of Hope

Matthew
NYU Child Study Center

It is important to remember 9-11-01 and to send the clear message we will always be one nation under god, and we will always remain as one. The U.S. will always be able to recover from attacks due to our love for one another.

Teekie
Notes of Hope

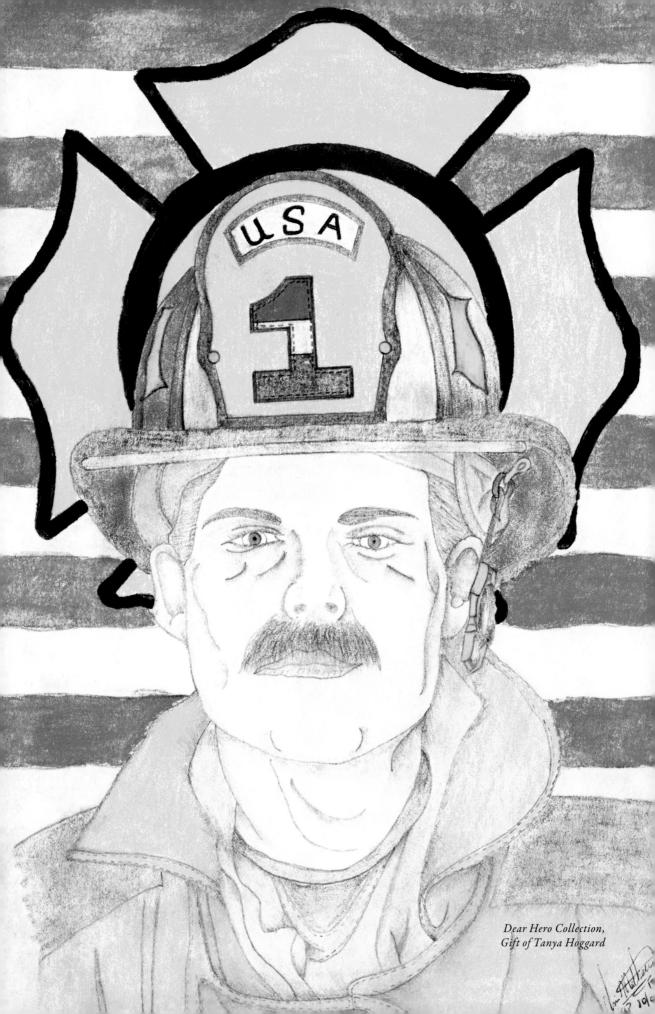

Dear Hero Collection,
Gift of Tanya Hoggard

Dear firemen and
rescue workers,

thanks for saving.
We're proud of you.

I don't know what we would
do without all you.

Americans are very lucky.

Cully
Dear Hero Collection,
Gift of Tanya Hoggard

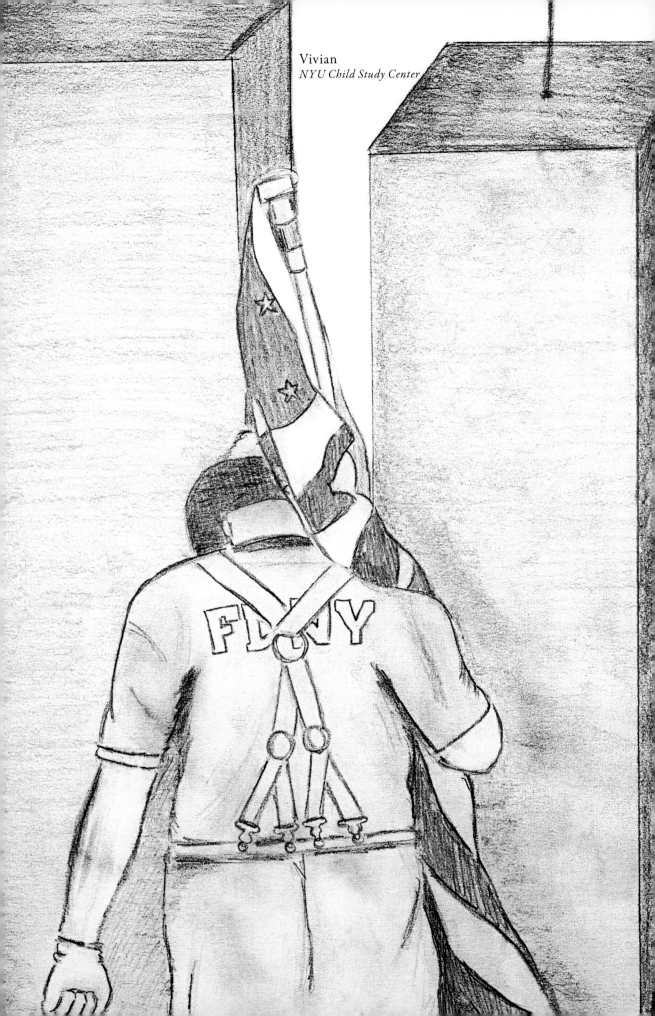

Vivian
NYU Child Study Center

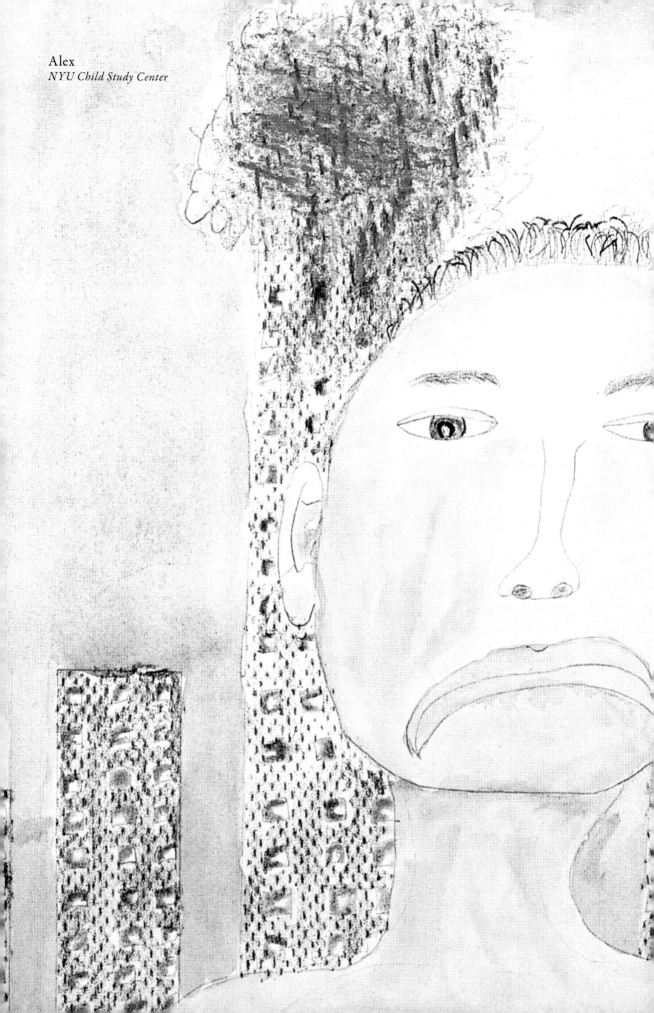

Alex
NYU Child Study Center

I WAS IN SCHOOL
WHEN I FIRST HEARD
WHAT HAPPENED.
I WOULD TELL **FUTURE
GENERATIONS** THAT
9/11 ONLY MADE
MY FAMILY **STRONGER,**
AND EVEN THOUGH
A LOVED ONE WAS
LOST, THIS DAY MADE
MY FAMILY MORE
CHERISHED. MANY
INNOCENT LIVES WERE
LOST THAT DAY.

Janine
Notes of Hope

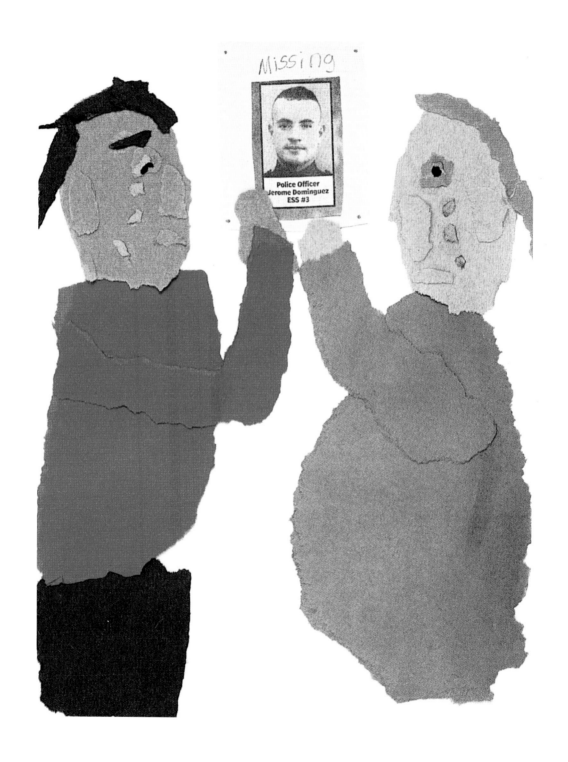

Nesita
NYU Child Study Center

ALASKA

was alive or not. Lucky for Me my sister cam home safely.

Manhattan and I didn't

On Sept 11, I
at school when
heard about
tragedy.
Plane crashed
into the
World Tr

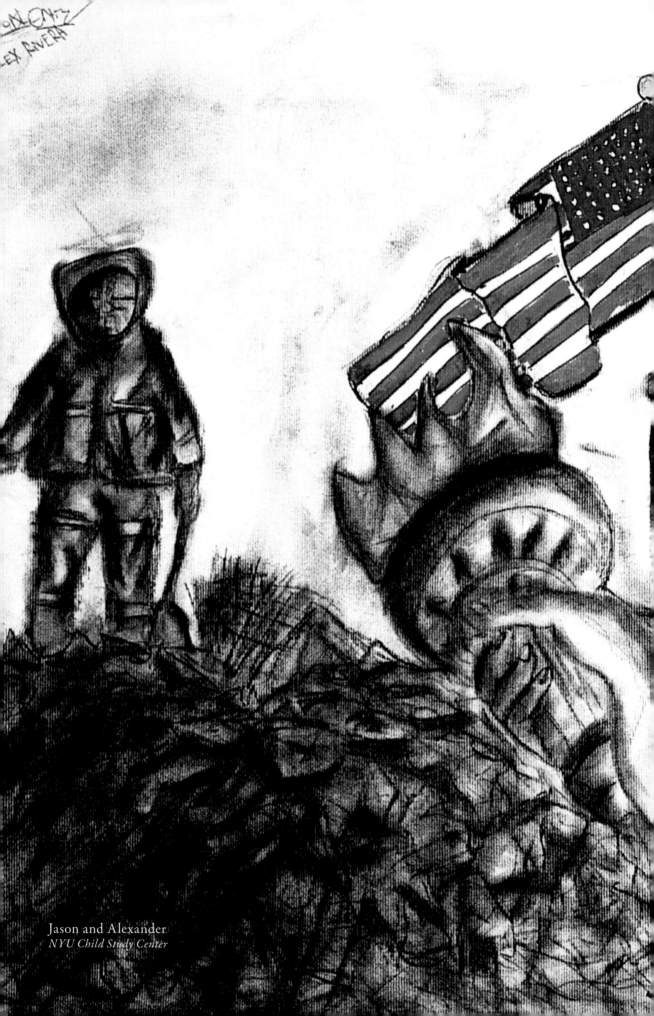

Jason and Alexander
NYU Child Study Center

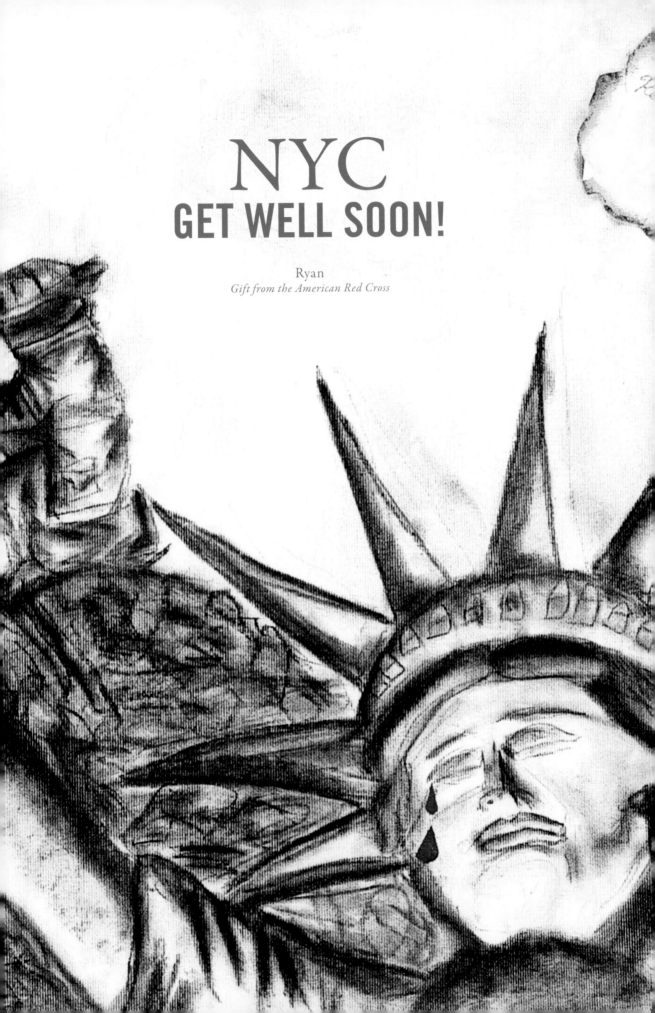

NYC
GET WELL SOON!

Ryan
Gift from the American Red Cross

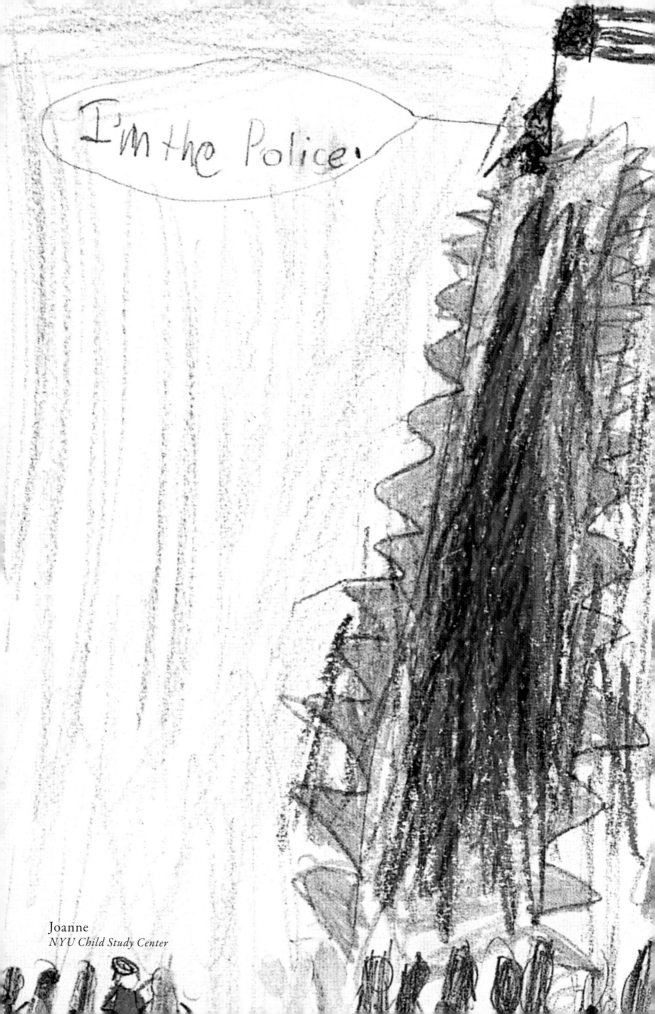

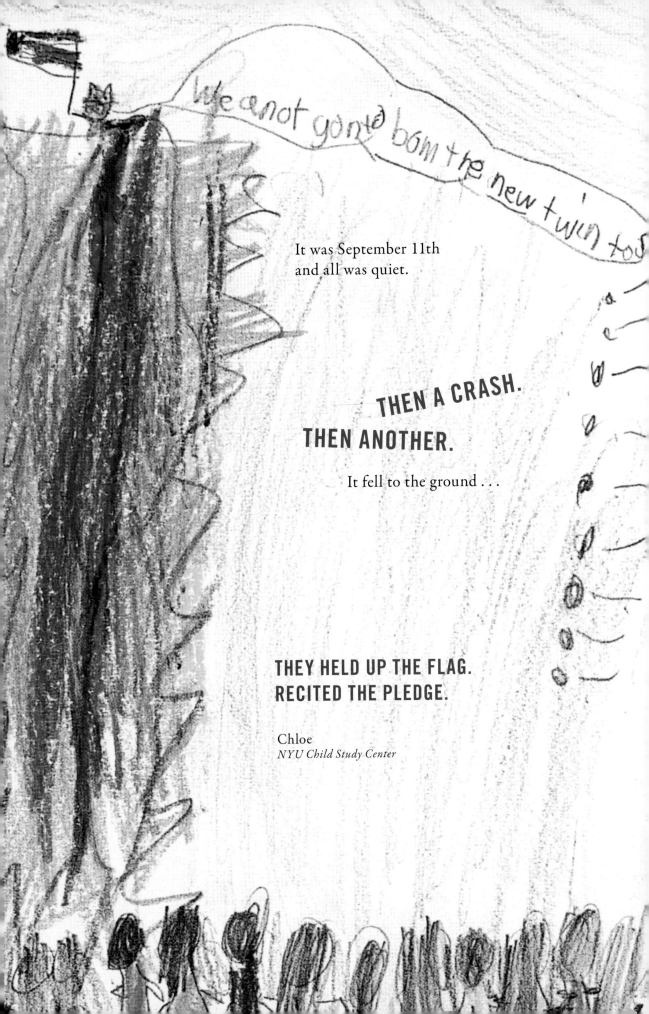

we a not gonta bom the new twin tos

It was September 11th
and all was quiet.

THEN A CRASH.
THEN ANOTHER.

It fell to the ground . . .

THEY HELD UP THE FLAG.
RECITED THE PLEDGE.

Chloe
NYU Child Study Center

PEACE IS THE ONLY HOPE

WE HAVE TO PRESERVE
FREEDOM . . . FOR ALL
PEOPLE IN THE WORLD.
THIS IS WHAT WE MUST
LEARN AND TEACH.

Christina
Notes of Hope

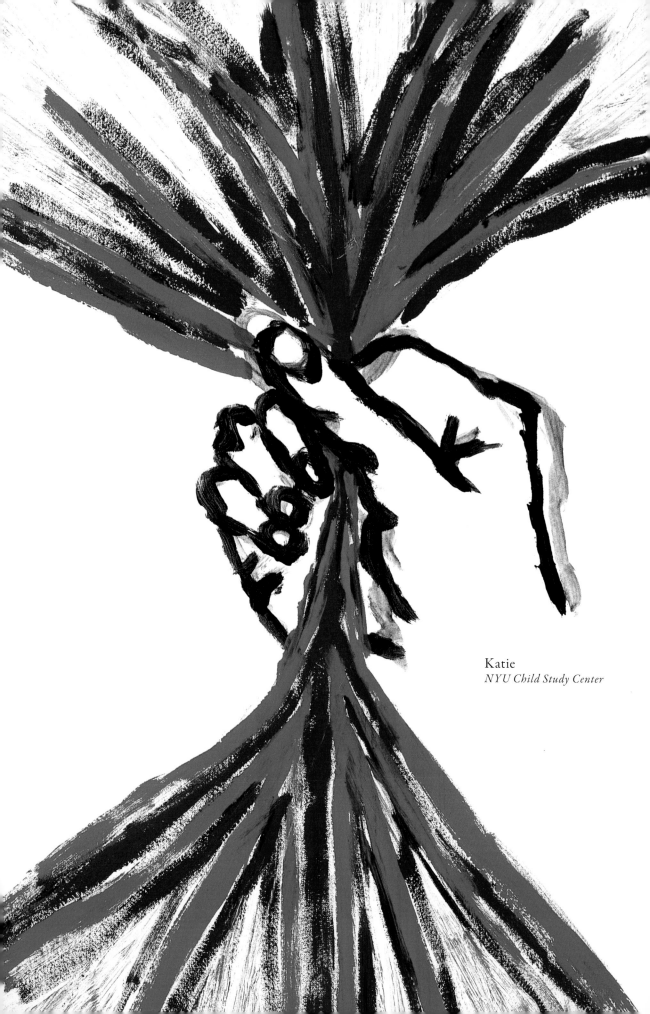

Katie
NYU Child Study Center

I was sitting in my 8th Grade history class

when I first heard.

I REMEMBER

everything about the day including

the first time I hear the name Osama Bin Laden.

I would love future generations to know the

PATRIOTISM

that came from that day.

Leslie
Notes of Hope

and I
feel vary bad
for the
people
who
dide

Melanie
NYU Child Study Center

Thank you so much for helping us 🖤

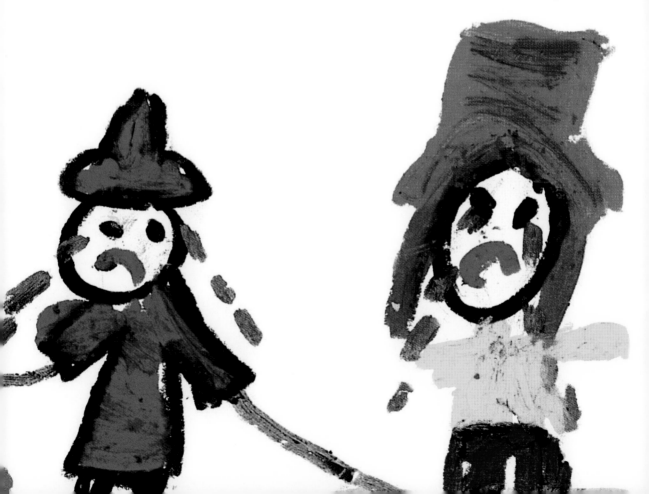

The night is always darkest before the dawn of a new day.

Steven
Notes of Hope

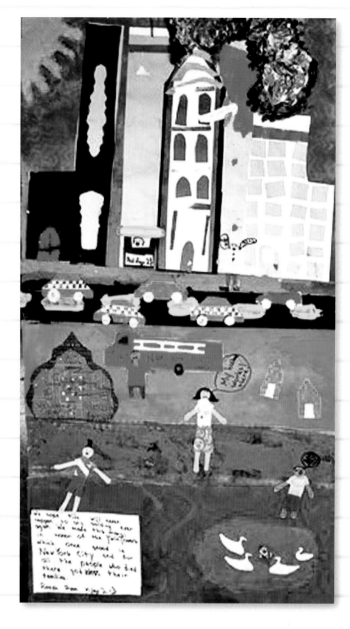

Art for Heart

At least the Twin Towers have each other and could say their last words. I would hope I could tell anyone I knew how much I cared.

Andrew
NYU Child Study Center

On September 11, 2001, people lost
loved ones and friends.

Many firemen, police, and anyone who
wanted to help came
and picked up debris.

America shall prevail.
The terrorists will not win.

Carla
NYU Child Study Center

Matthew
Detail: *NYU Child
Study Center*

WHAT I WILL MISS
MOST ABOUT
YOU IS WHEN YOU
HELP ME WITH
MY HOMEWORK,
TEACH ME SPORTS…
IF I COULD TELL YOU
ONE MORE THING,
IT IS I MISS YOU
DADDY AND PLEASE
LOOK OUT FOR ME,
BRIAN, KERRY AND
MOMMY. I WILL ALWAYS
LOVE YOU DADDY.
HAPPY BIRTHDAY
TO MY HERO!

Caitlin
Notes of Hope

CRAIG Montano
MY Daddy
I Love You!!
Liam
2½ Yrs. old

We miss you
Daddy

I
For m

DAD.

I mi
you o

I mi
you d

DADDY

I love my

I LOV

Daddy I love

To my daddy Yo

LOVE father

Daddy Seth Morris
Love
Hayley

We ♥ You Uncle
Geoff

For My Dad Seth Morris

I remember

riding on

Daddy's shoulders

E

Art for Heart

ou Dad LU KAS. YOU

our Hero I LOVE

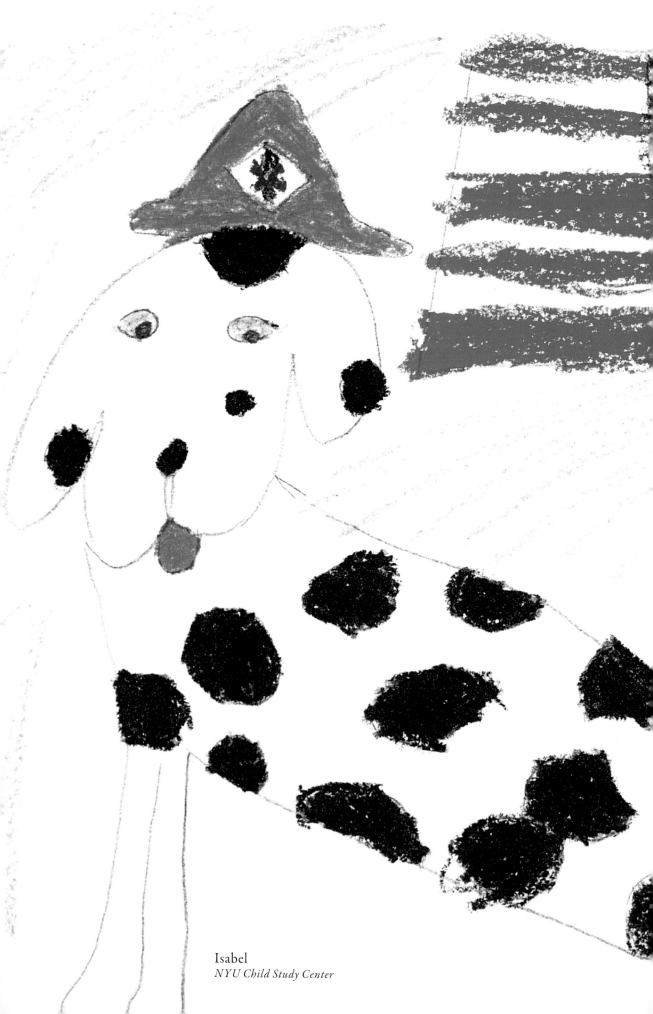

Isabel
NYU Child Study Center

dollars. Recently I held a toy sale. I have been saving it for you
[the NYC Fire Department]. I raised thirty-five
God bless you, and God bless America.

Kyle
Dear Hero Collection,
Gift of Tanya Hoggard

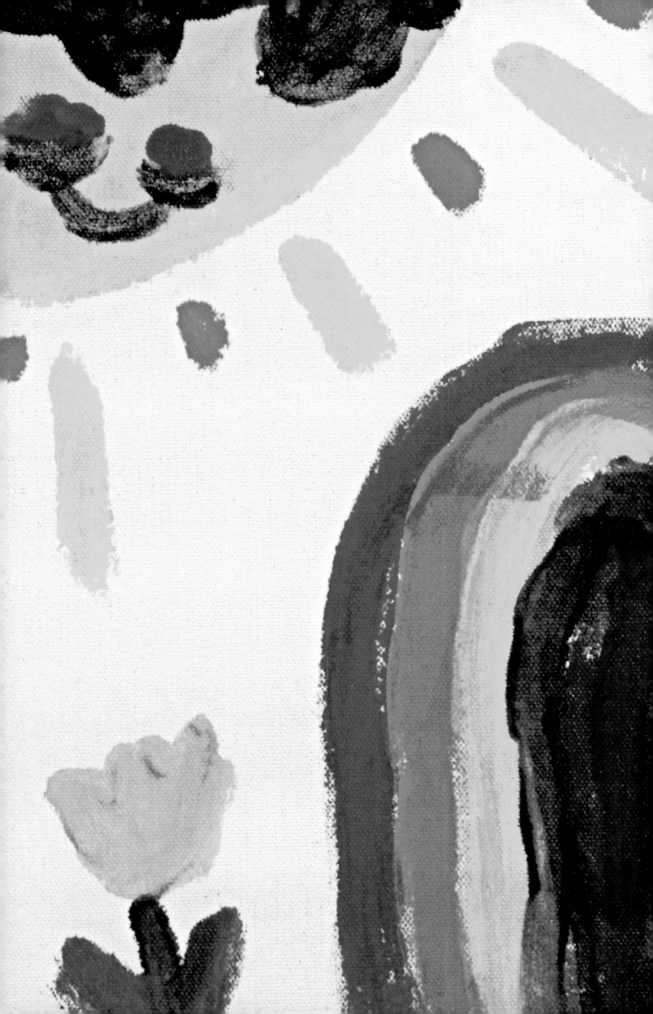

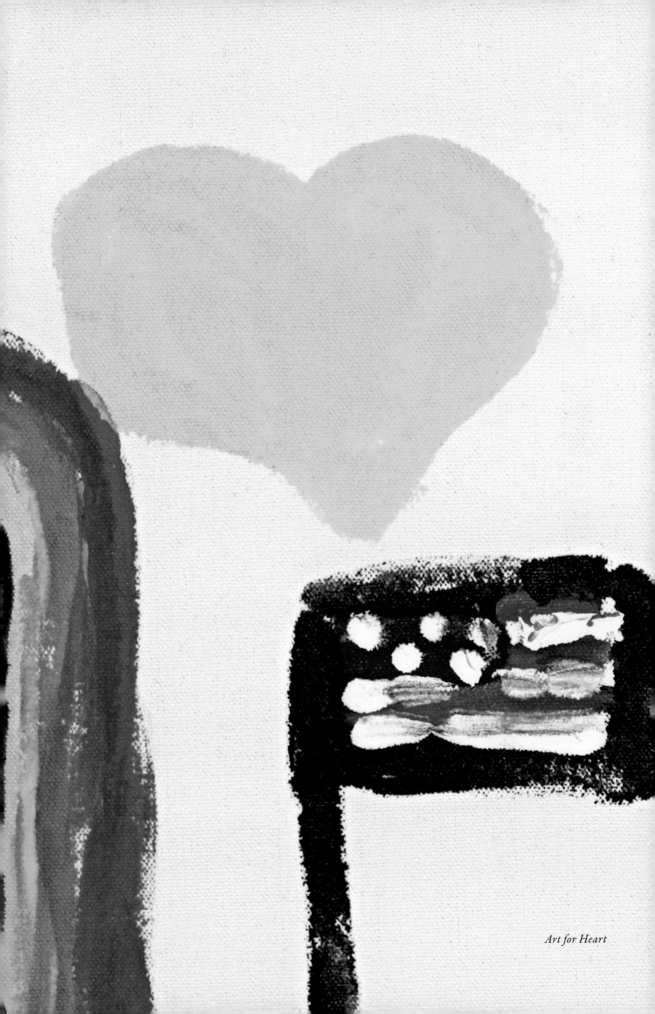

Art for Heart

IN
EVERY
tragedy
HOPE CAN
BE FOUND AND
A NEGATIVE CAN
BE TURNED INTO A
POSITIVE. WE HAVE
NO CONTROL OVER WHETHER
OR NOT AN EVENT WILL **CHANGE**
OUR *lives* — IT WILL. WE
DO CONTROL HOW IT CHANGES US.
WE MUST BECOME BETTER.

Kasey
Notes of Hope

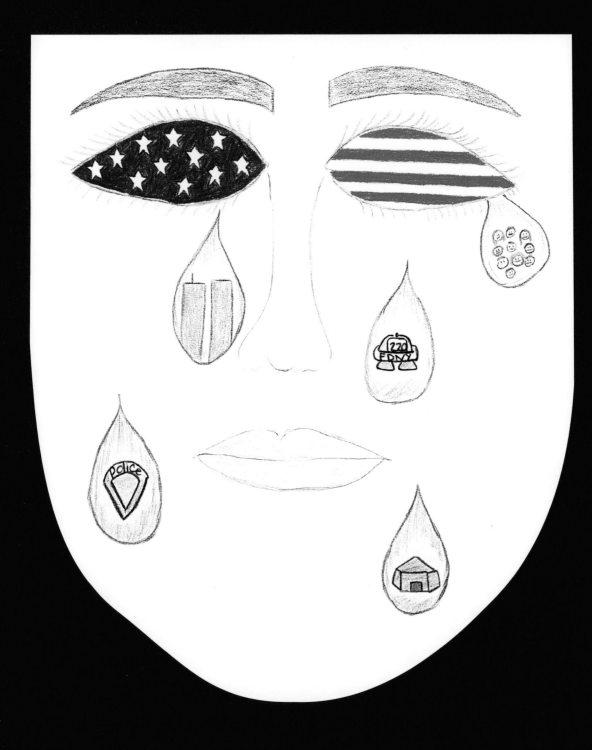

Meghan
NYU Child Study Center

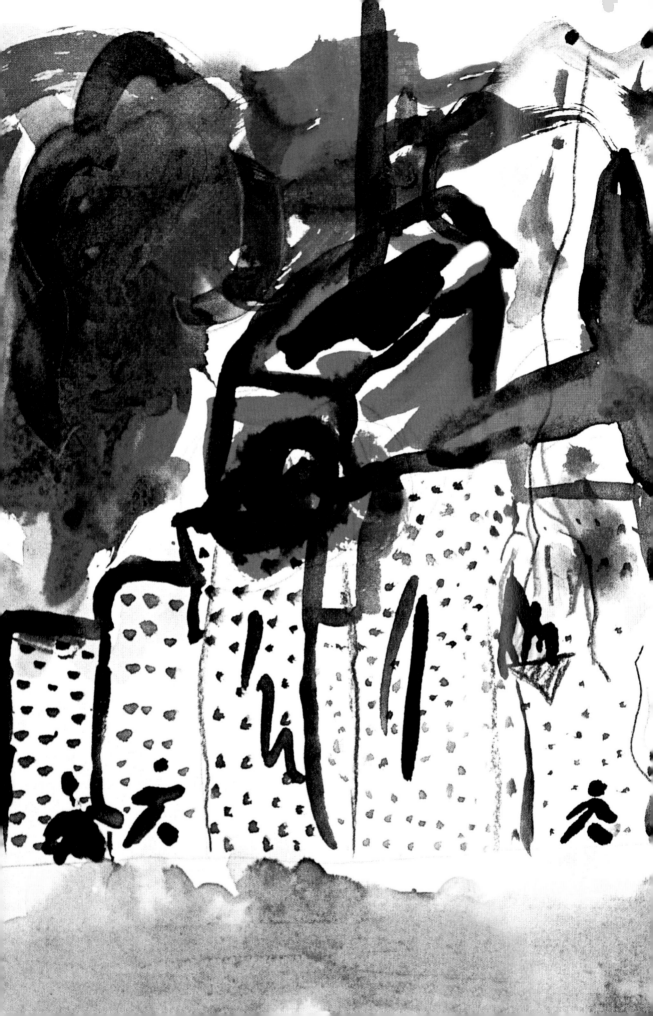

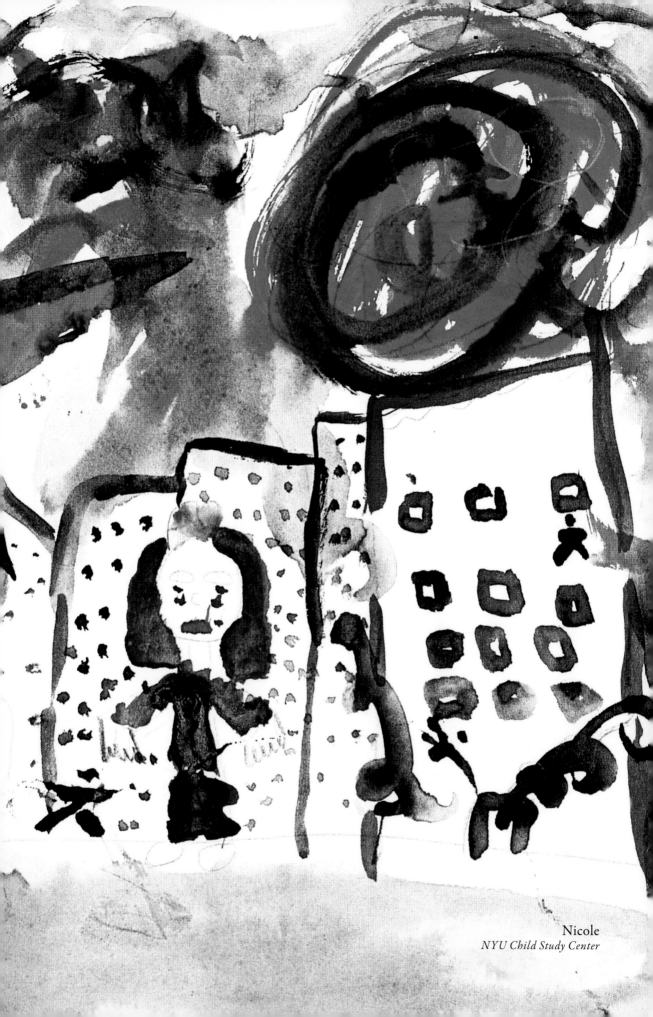

Nicole
NYU Child Study Center

I was thirteen when 9/11

occurred and I believe,

for my generation,

that date was the first

event of **SIGNIFICANCE** that

defined us and

our view of the world.

It also gave us

our first real experience with

COURAGE and **SPIRIT**.

Caitlyn
Notes of Hope

Art for Heart

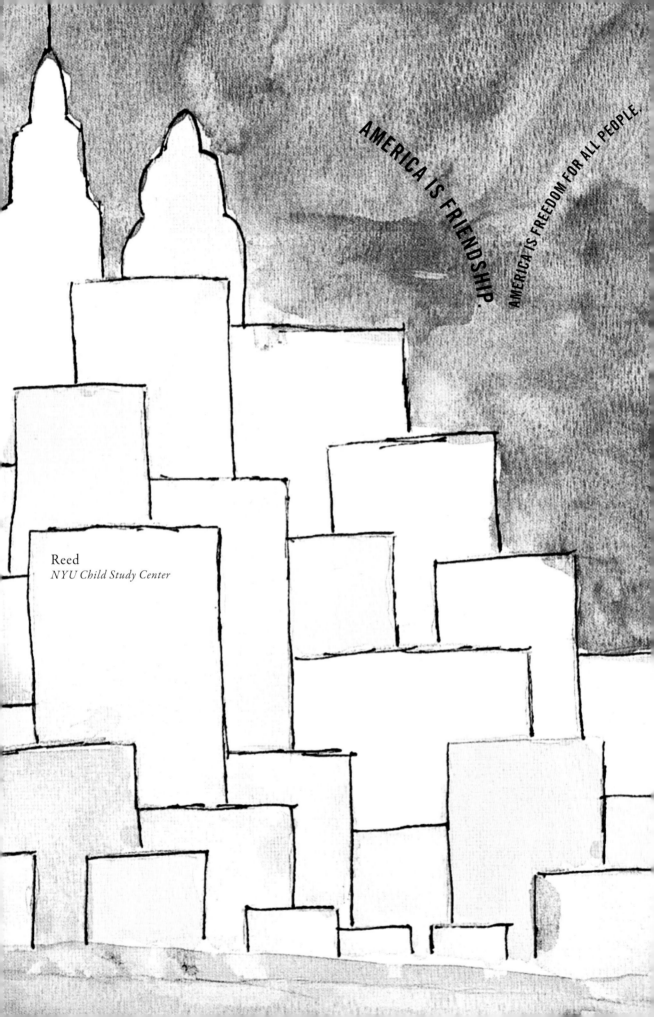

AMERICA IS FRIENDSHIP.

AMERICA IS FREEDOM FOR ALL PEOPLE.

Reed
NYU Child Study Center

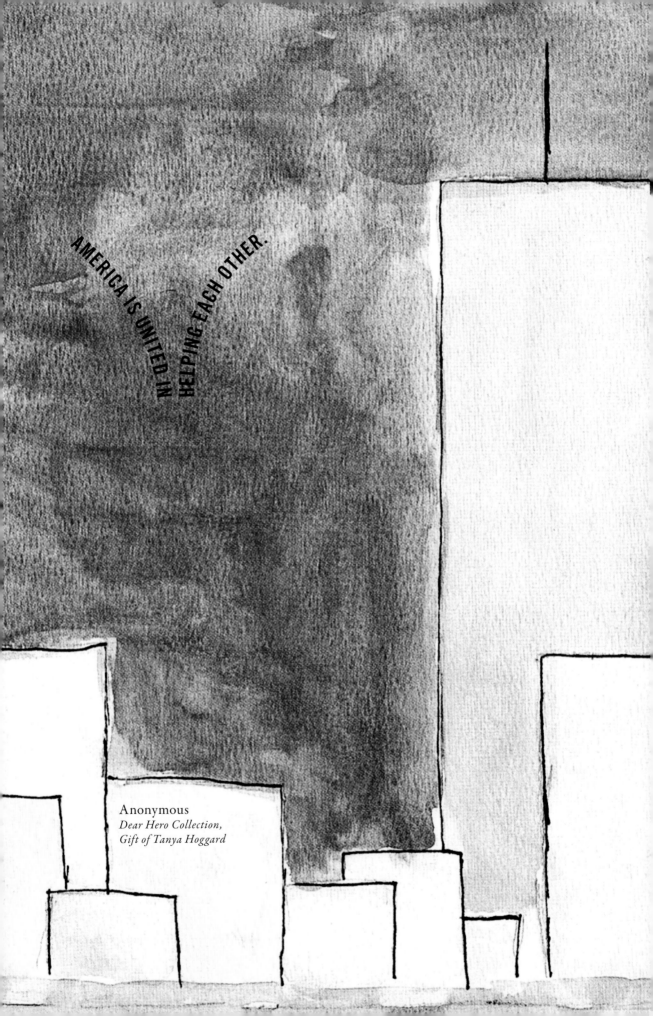

AMERICA IS UNITED IN HELPING EACH OTHER.

Anonymous
Dear Hero Collection,
Gift of Tanya Hoggard

9/11

Having just graduated college a couple of months ago, it is amazing how my life has been shaped by one day back in the beginning of high school . . .

I was a freshman in high school on

Katie
Notes of Hope

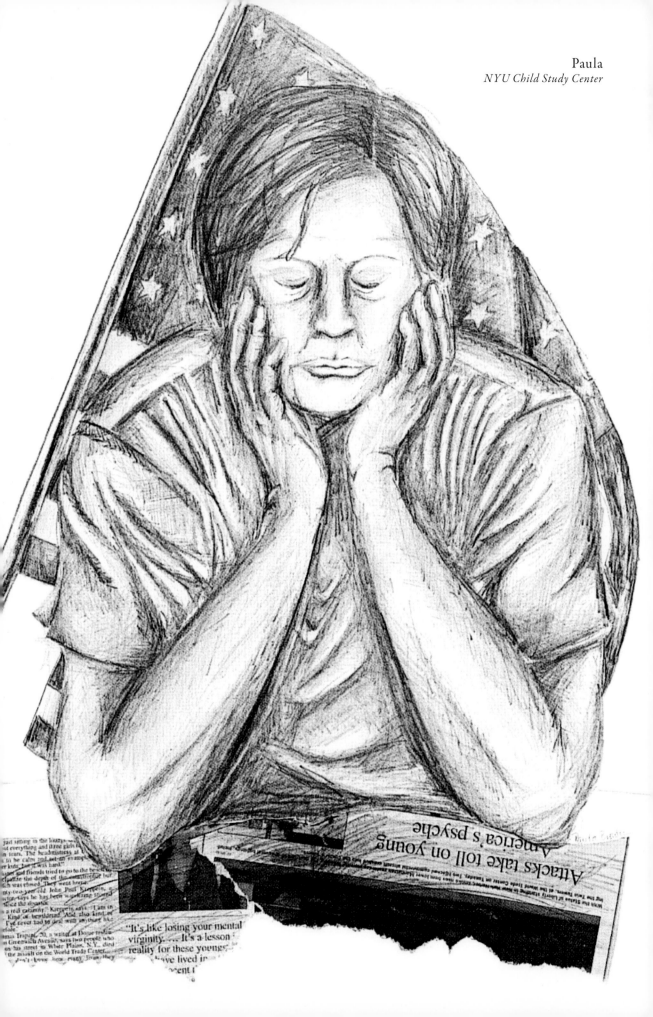

Attacks take toll on young
America's psyche

"It's like losing your mental
virginity. . . . It's a lesson
reality for these younge.
ve lived in
vent t

In fifth grade

Changed my world
I am no longer a child who

grew up without war.

Jane
Notes of Hope

In Memory Of my DADDY

JASON K. JACOBS

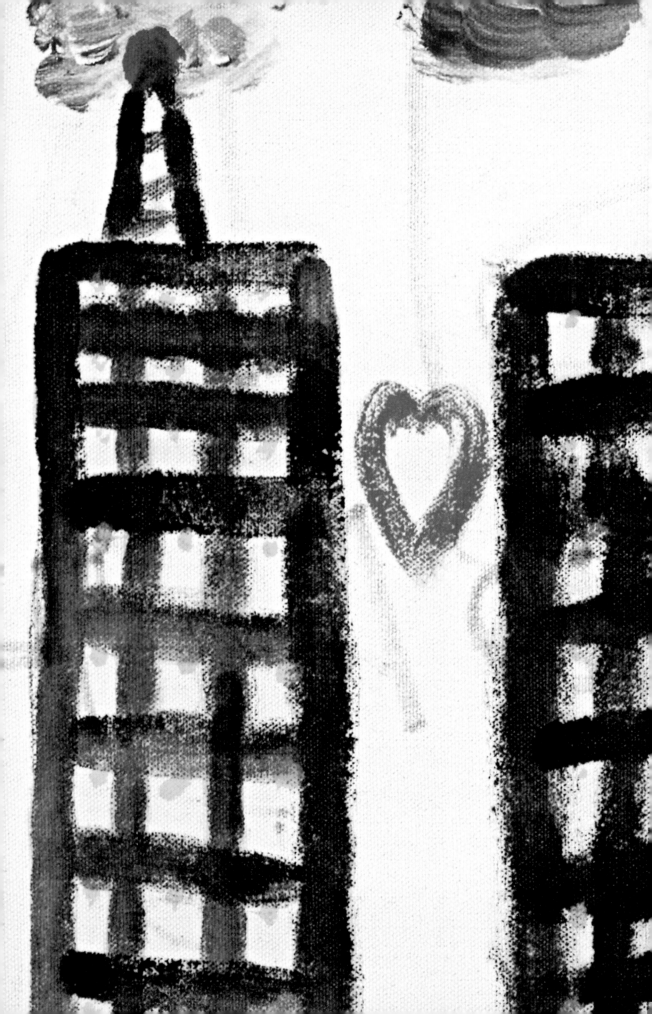

Art for Heart

Art for Heart

On 9/11 I was a sophomore in high school. I walked into class and heard someone talking about a new movie, only later I learned the events were horribly real. I dedicate my career to remembering what happened here. Never forget or repeat.

Tiffany
Notes of Hope

heart broken pain

On Sept. 11 I was
at school when I heard about the
tragedy. I felt
Pain

heart broke
Broken
pain
no love
darkness

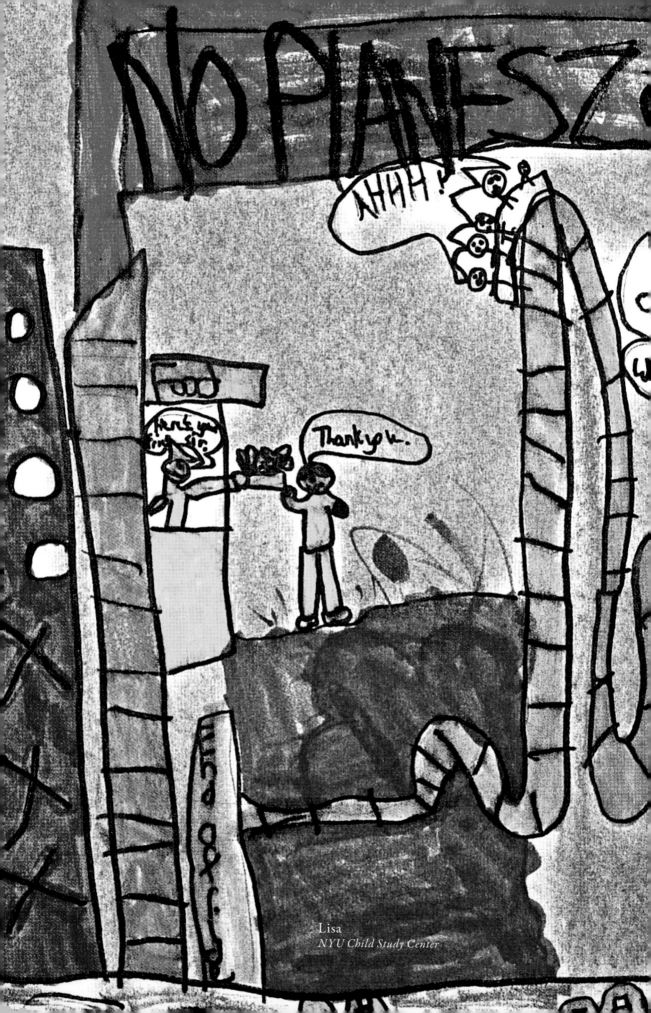

Lisa
NYU Child Study Center

Seeing
people
of all
different
races
coming

TOGETHER

is
really
amazing.

Matthew
NYU Child Study Center

I was in second grade when my mom woke me up and tried to explain what was happening. I think I got it but now I really understand, and I hope that this will never happen again anywhere.

Sandra
Notes of Hope

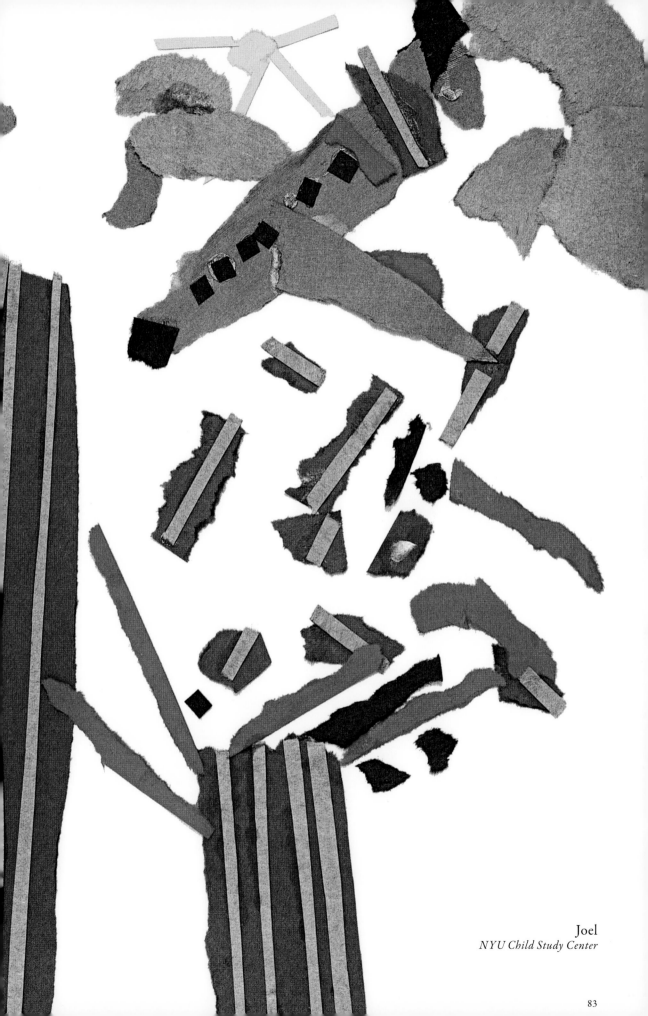

Joel
NYU Child Study Center

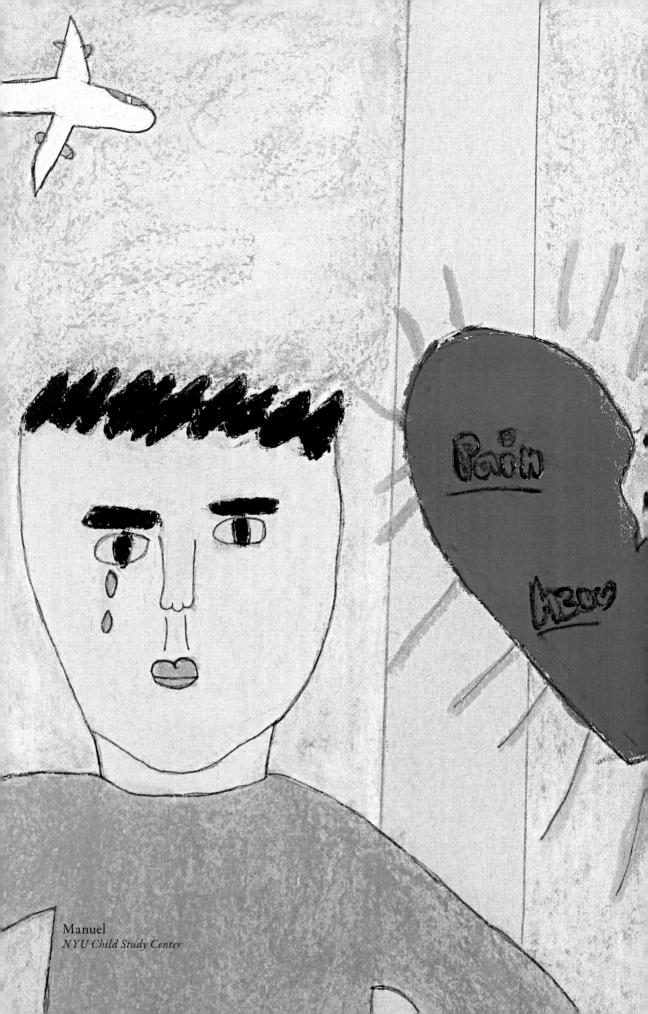

Manuel
NYU Child Study Center

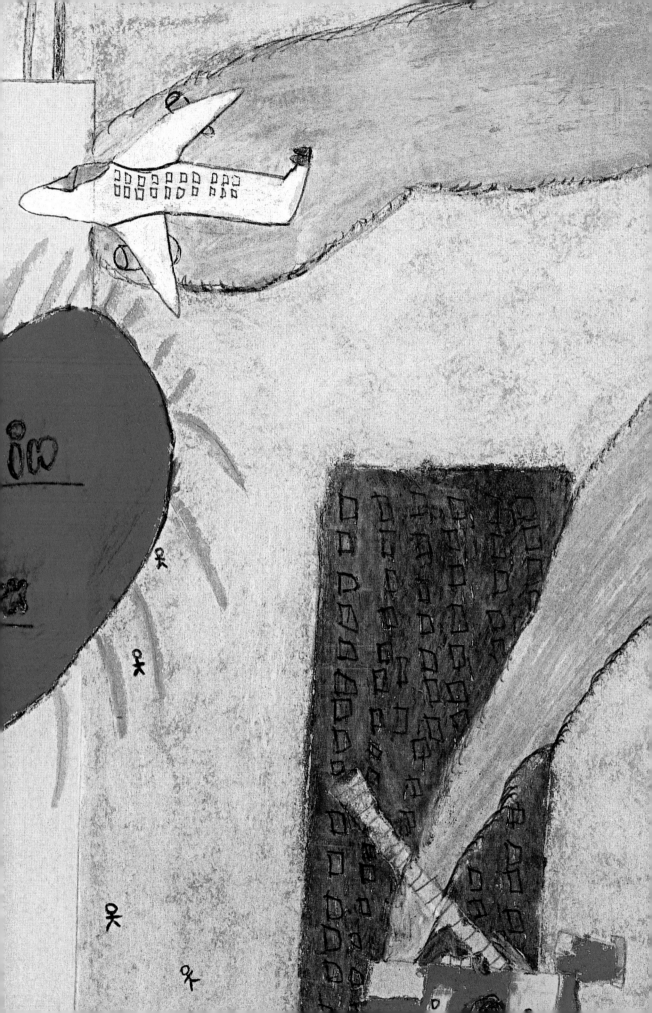

My
drawing
is of
a hand
gripping
America.
This
expresses
the U.S.A.'s
strength
and ability
to shine.

Katie
NYU Child Study Center

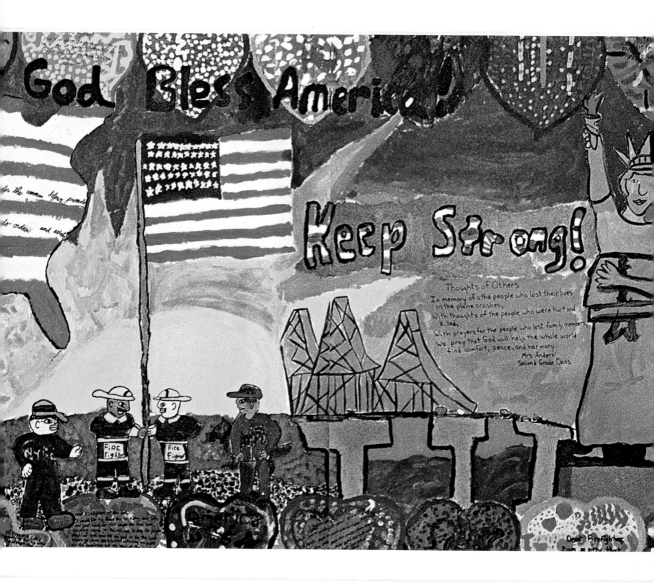

We need to remember that life can change in the blink of We are one country, one people. No matter where we live

Mural (detail) created by the Lower School Art Students of Porter Gaud School in Charleston, South Carolina, in Mrs. Laura Orvin's art class for the people of New York. Gift of Lawrence Knafo.

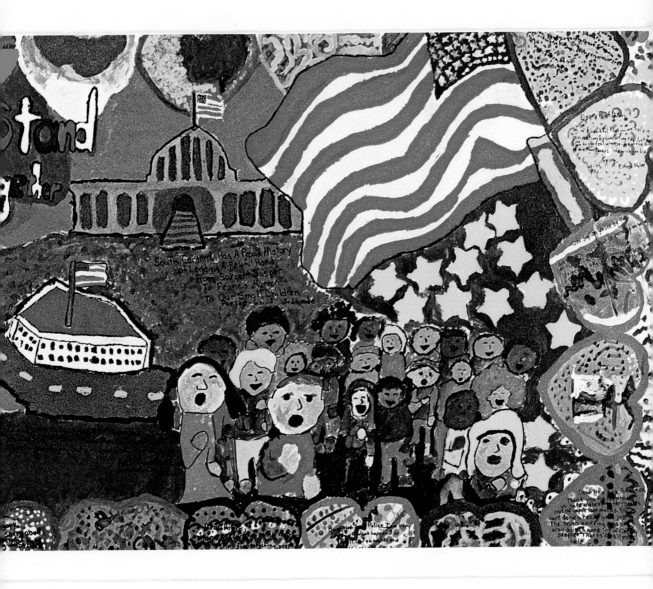

an eye, caused by circumstances out of our hands.

in the U.S. we must always remember.

Julie
Notes of Hope

Poppy
Killed
Here

I WAS AT SCHOOL.
I REMEMBER WATCHING IT AT SCHOOL.

NOW I'M A JUNIOR FIREFIGHTER.

Nolan
Notes of Hope

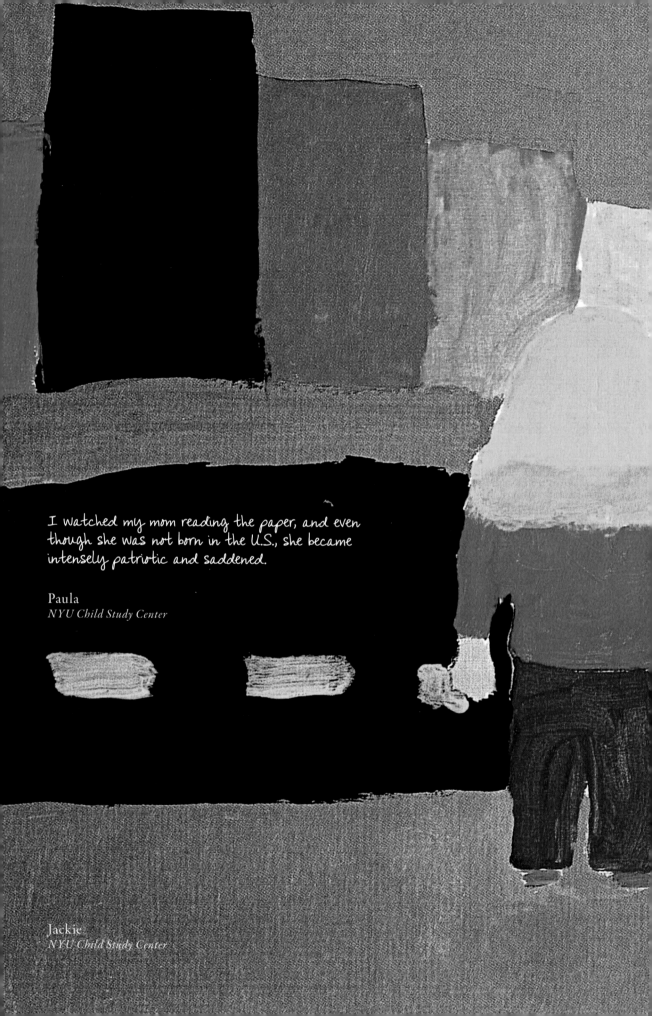

I watched my mom reading the paper, and even though she was not born in the U.S., she became intensely patriotic and saddened.

Paula
NYU Child Study Center

Jackie
NYU Child Study Center

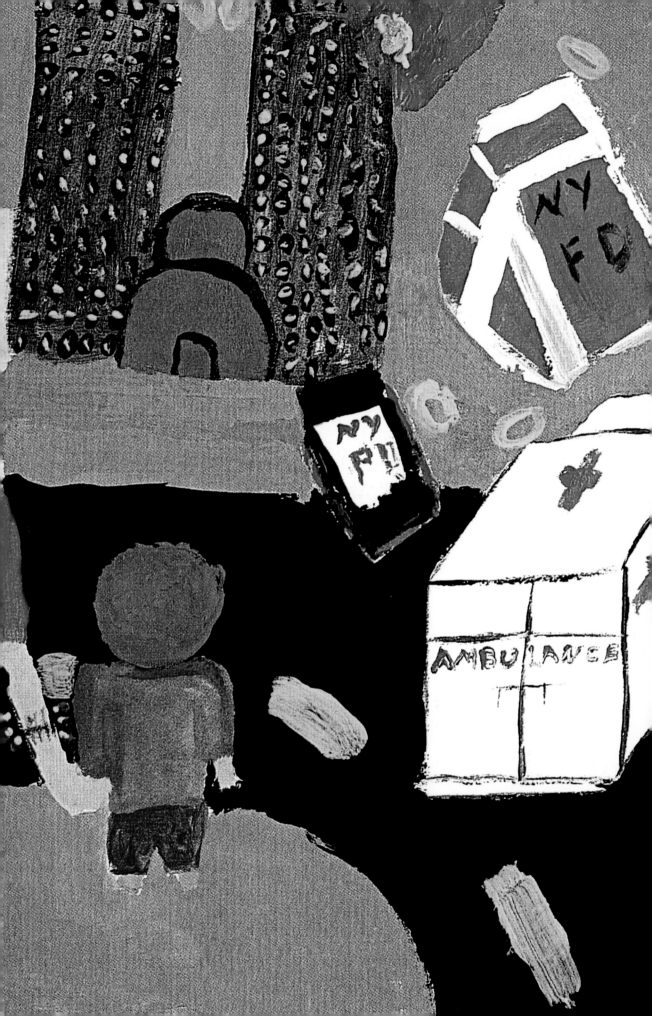

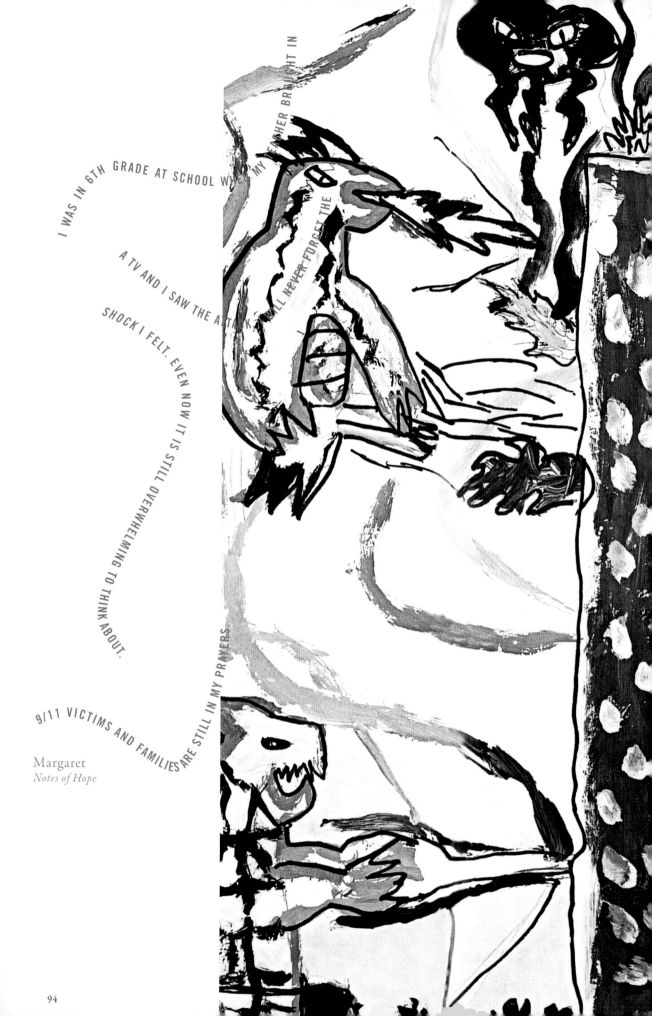

I WAS IN 6TH GRADE AT SCHOOL WHEN MY TEACHER BROUGHT IN A TV AND I SAW THE ATTACK. I WILL NEVER FORGET THE SHOCK I FELT. EVEN NOW IT IS STILL OVERWHELMING TO THINK ABOUT. 9/11 VICTIMS AND FAMILIES ARE STILL IN MY PRAYERS.

Margaret
Notes of Hope

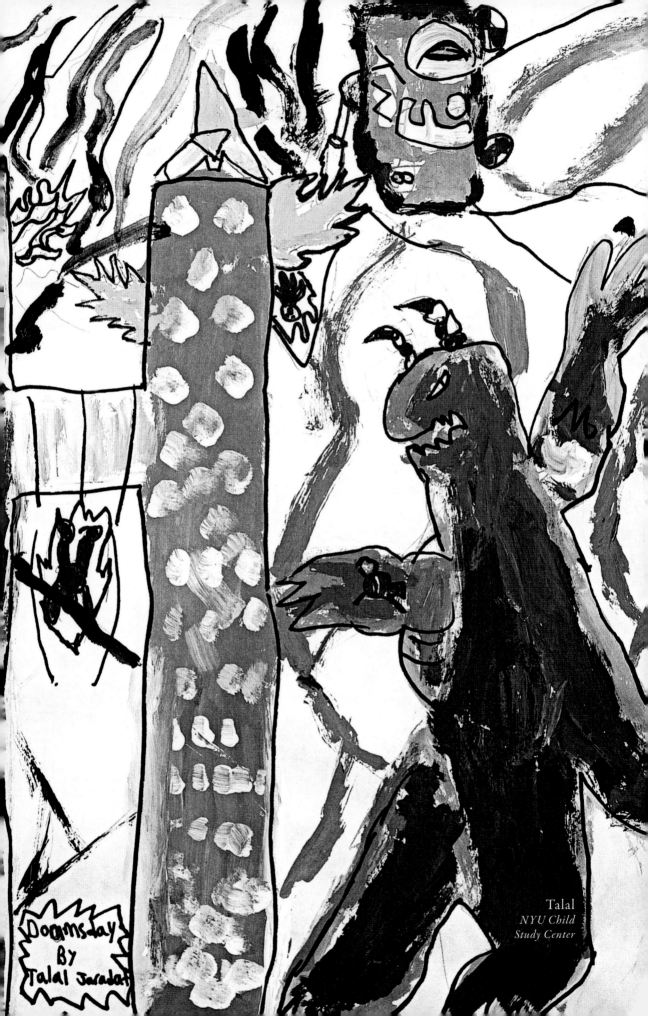

Doomsday
By
Talal Jaradat

Talal
NYU Child
Study Center

I was in my 5th Grade
classroom sleeping ✳
We heard airplanes
flying constantly
but I really didn't care ✳

THEN THE TEACHER LEFT
AND CAME BACK AND SAID ✳ ✳ ✳

Asley
Notes of Hope

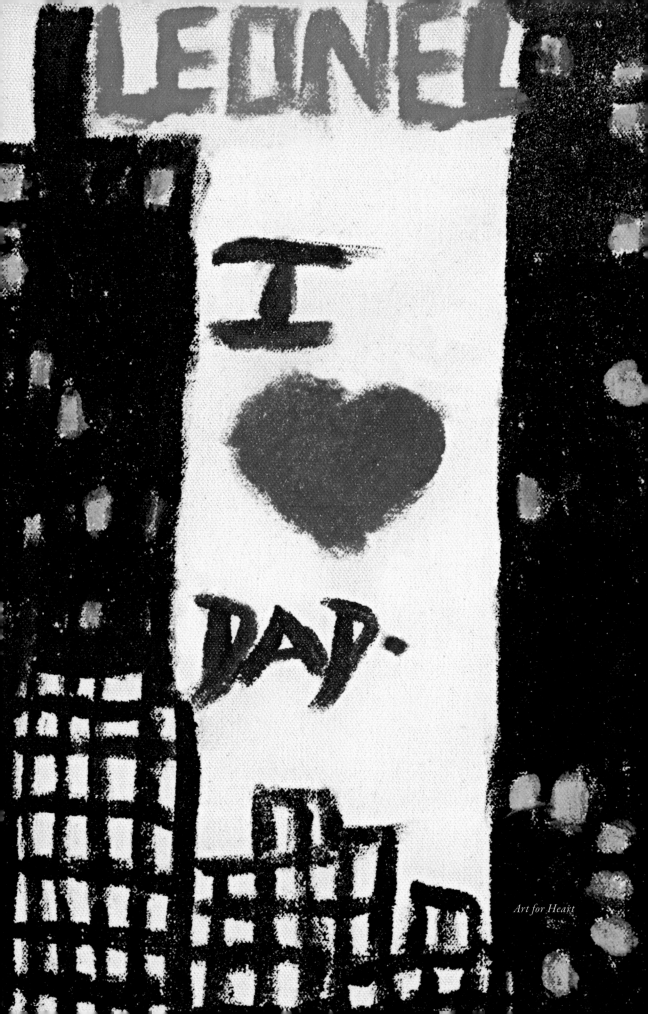

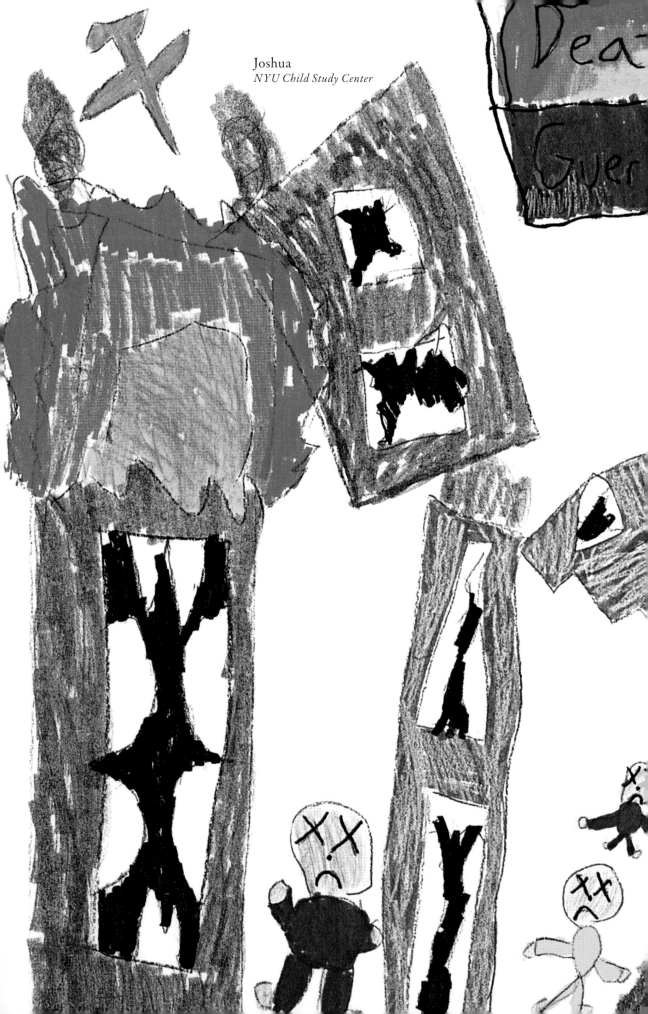

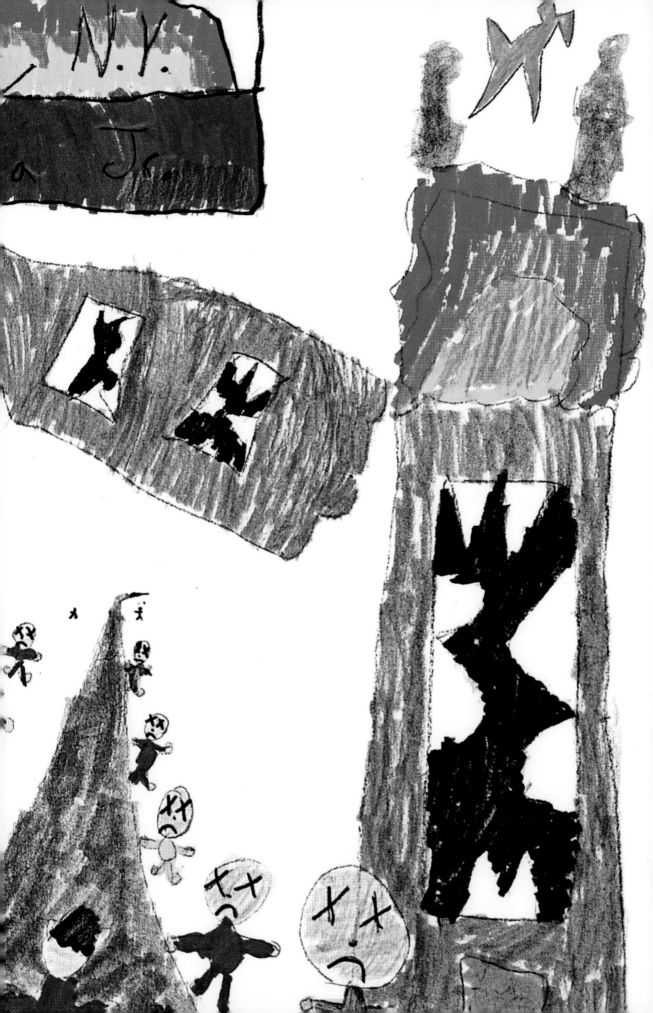

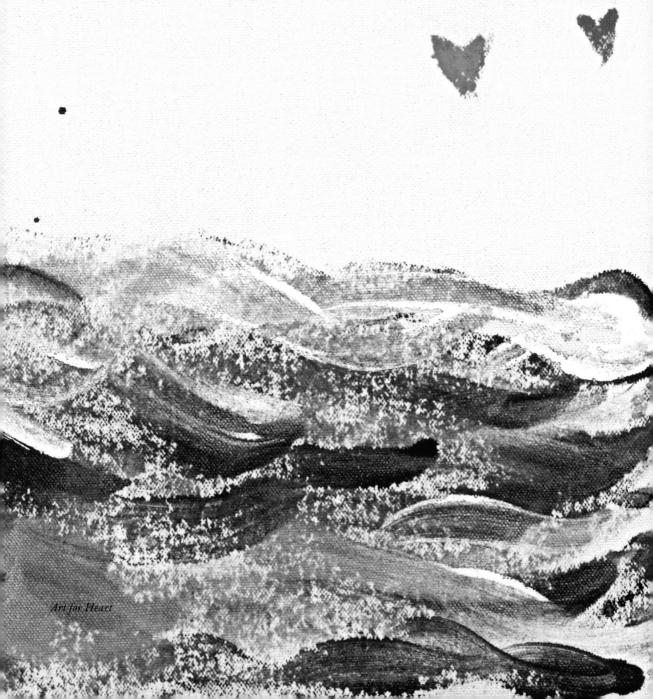

Art for Heart

Was
sitting in my high school
class and remembered thinking how this
would change everything. Was sitting in my high
school class and remembered thinking how this would
change everything. Was sitting in my high school class and re-
membered thinking how this would change everything. Was sit-
ting in my high school class and remembered thinking how this would
change everything. Was sitting in my high school class and remembered
thinking how this would change everything. Was sitting in my high school
class and remembered thinking how this would change everything. Was sit-
ting in my high school class and remembered thinking how this would change
everything. Was sitting in my high school class and remembered thinking
how this would change everything. Was sitting in my high school class and
remembered thinking how this would change everything. Was sitting in
my high school class and remembered thinking how this would change
everything. Was sitting in my high school class and remembered
thinking how this would change everything. Was sitting in my
high school class and remembered thinking how this would
change everything. Was sitting in my high school
class and remembered thinking how this
would change everything.

Chris
Notes of Hope

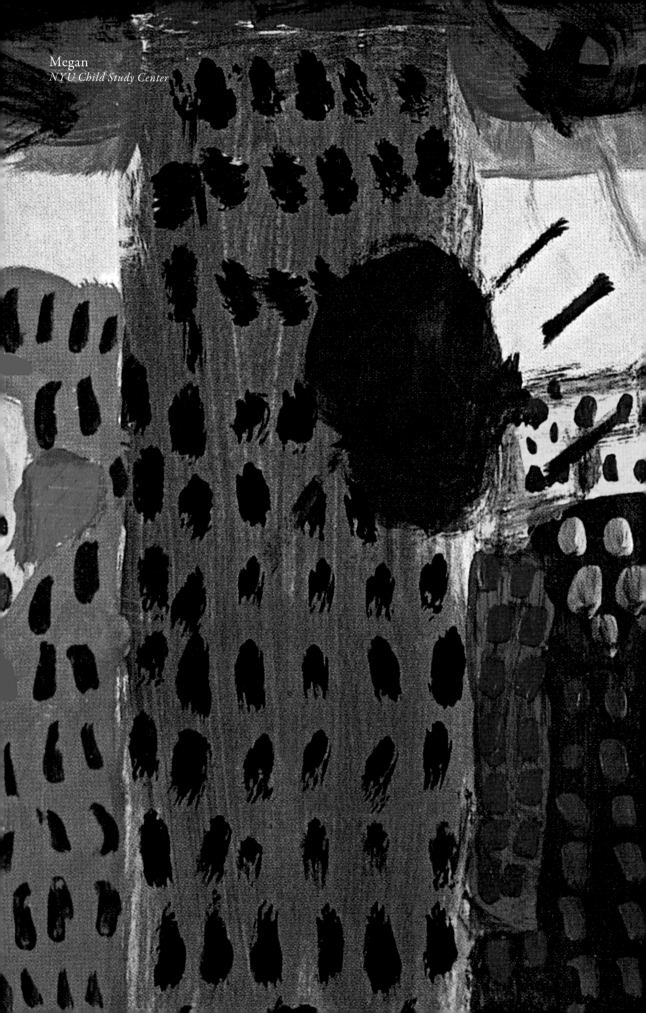

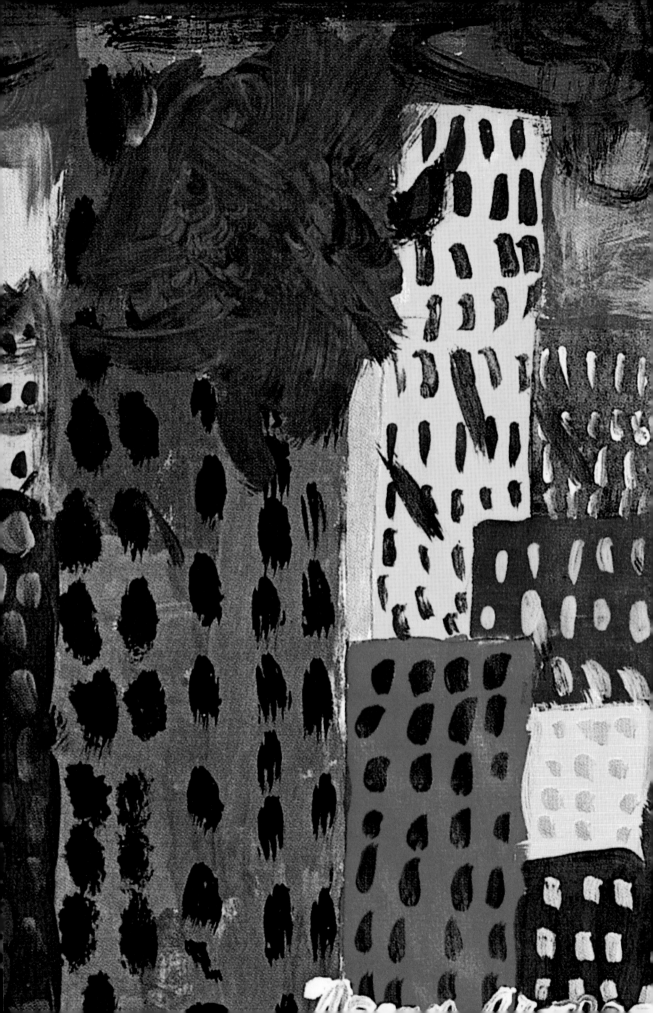

I was **13** when the towers **fell**.

There are few consistent things in a 13-year-old's life.

There is your SCHOOL, **FAMILY**, and your COUNTRY.

To see my United States not only survive but **strengthen** through **tragedy** makes me

American PROUD.

Alyssa
Notes of Hope

Andrew
NYU Child Study Center

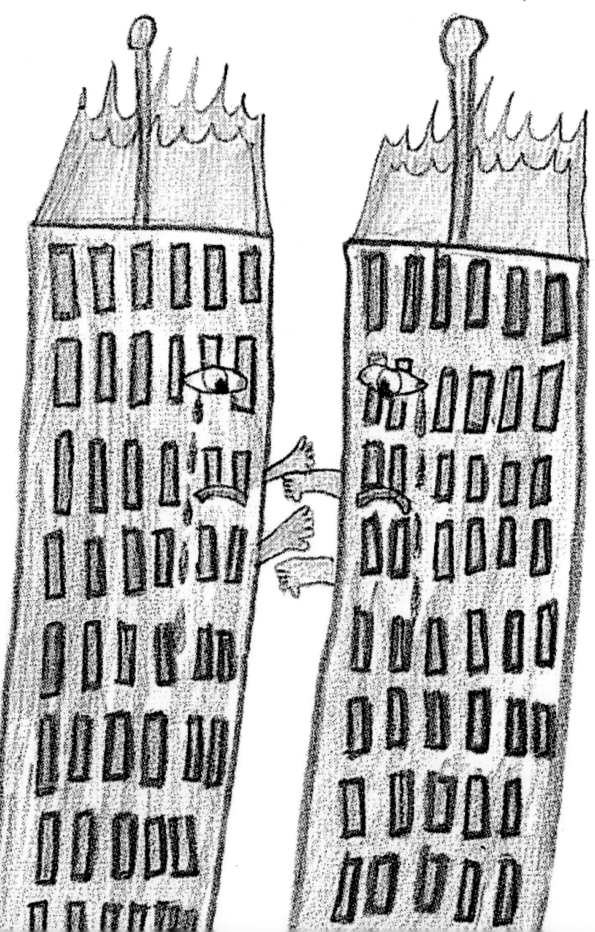

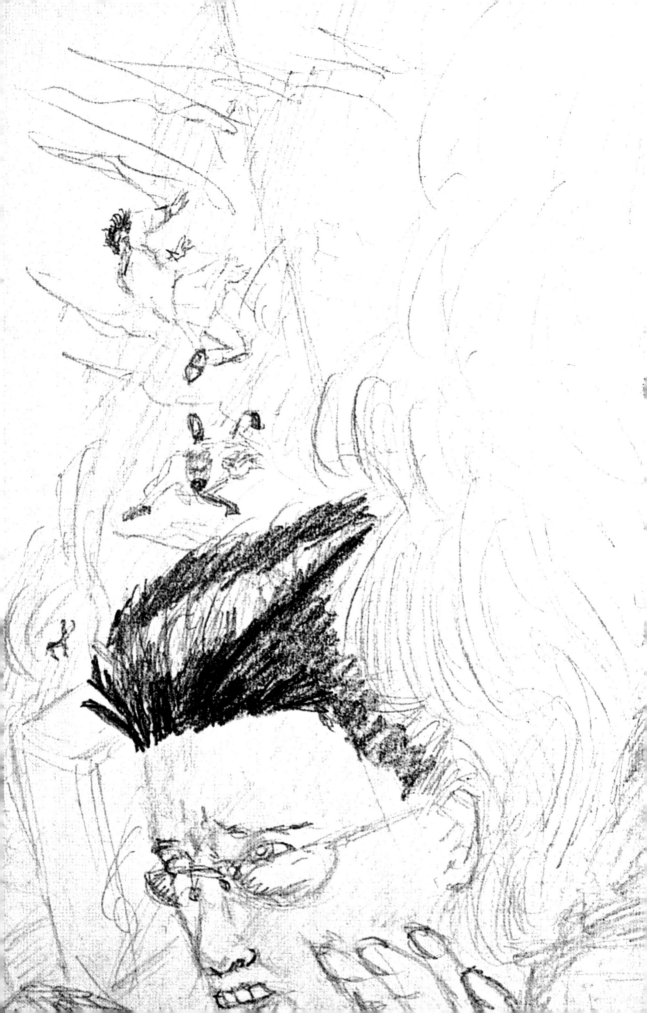

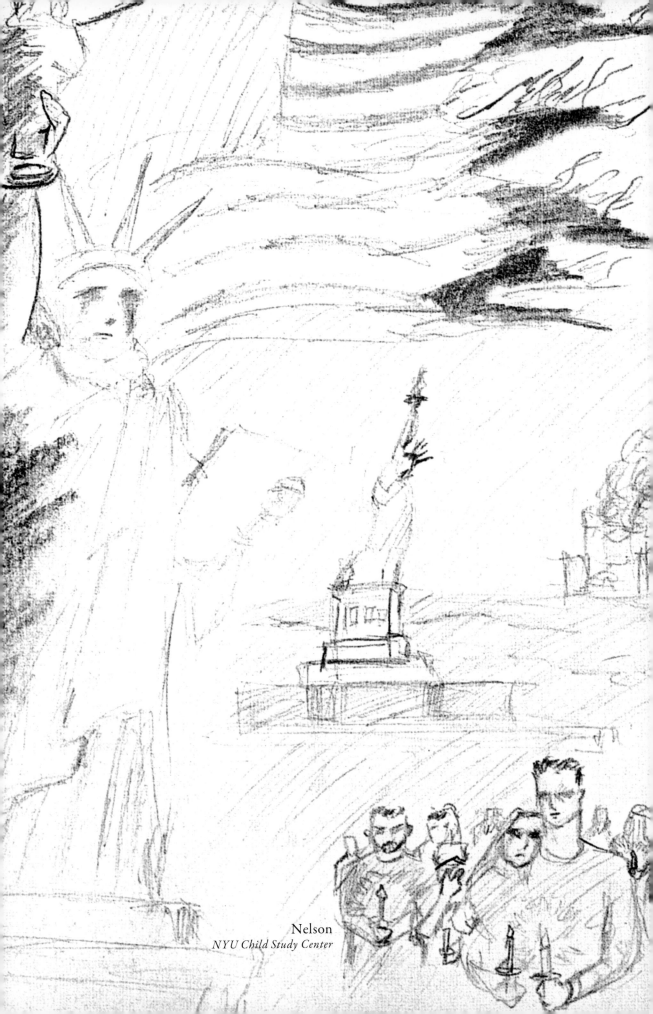

Nelson
NYU Child Study Center

Dear Rescue Workers, Thank you for putting out the fire so people won't get hurt. Thank you for saving the Earth. You're the best. Thank you for helping people from the Twin Towers.

Jacob
Gift from the American Red Cross

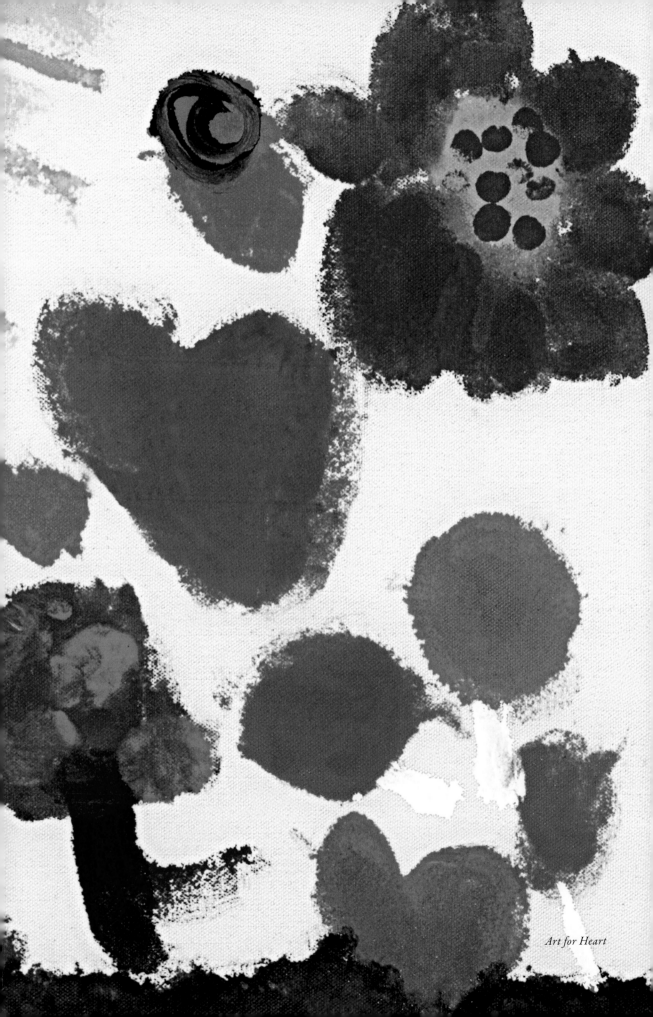

Art for Heart

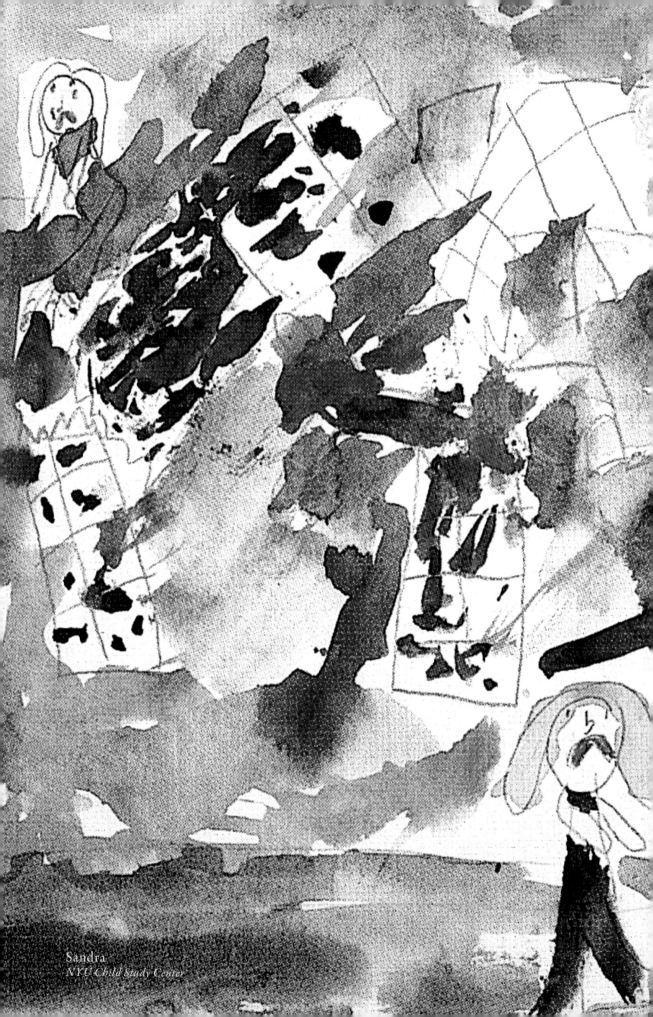

Sandra
NYU Child Study Center

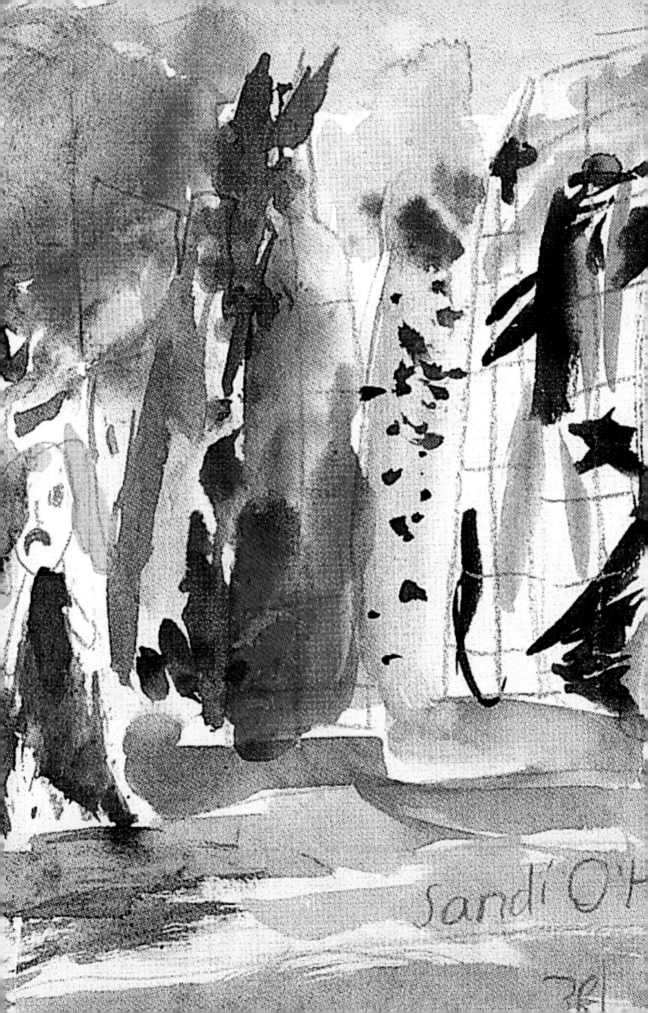

MY FATHER WORKED ON THE 106TH AND 107TH FLOORS OF THE WTC BUILDING NUMBER ONE. LUCKILY HE WASN'T THERE.

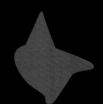

Andrew
NYU Child Study Center

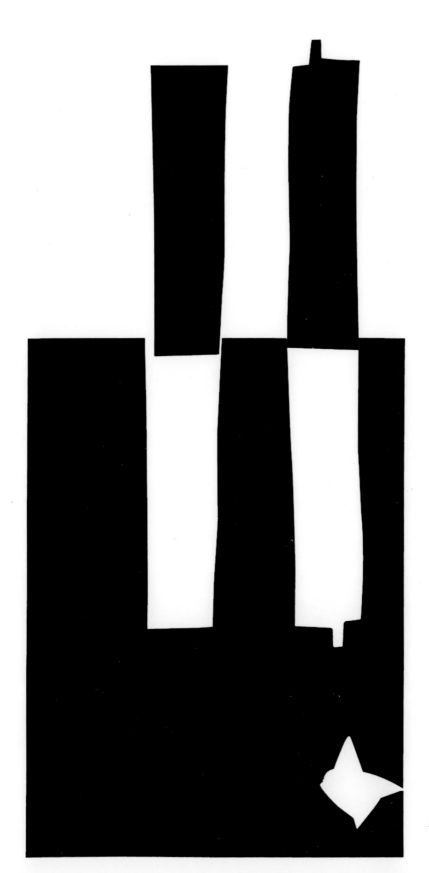

Andrew
NYU Child Study Center

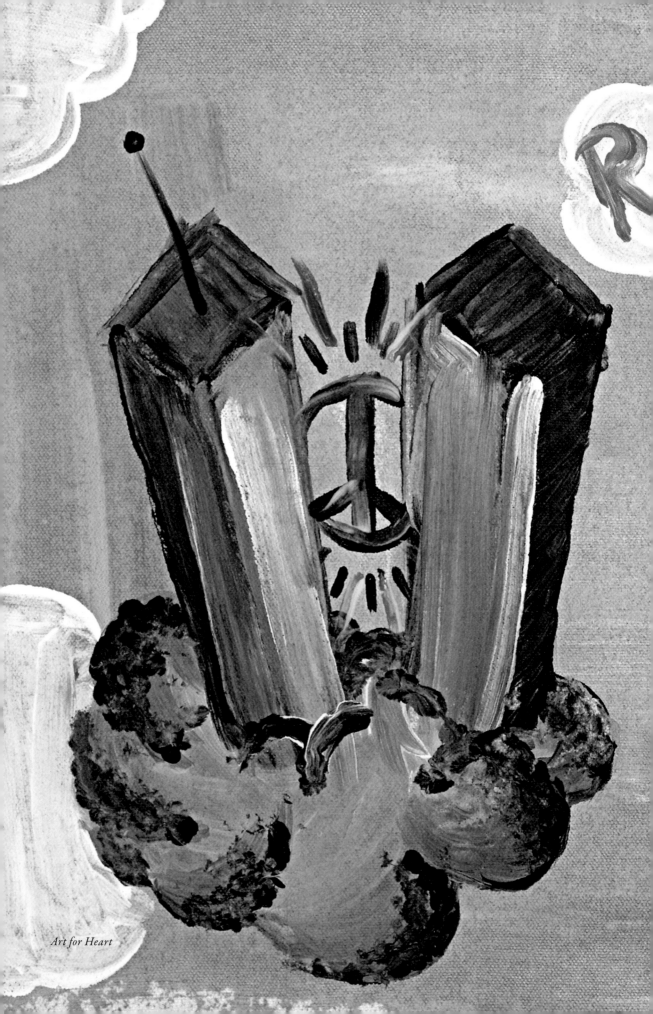

Art for Heart

Art for Heart

The **tragedy** that day brought

the world together in a rare display of

Compassion and *Solidarity*.

My prayer is to have such a world

again that will be compassionate

and *Peaceful*.

Roger
Notes of Hope

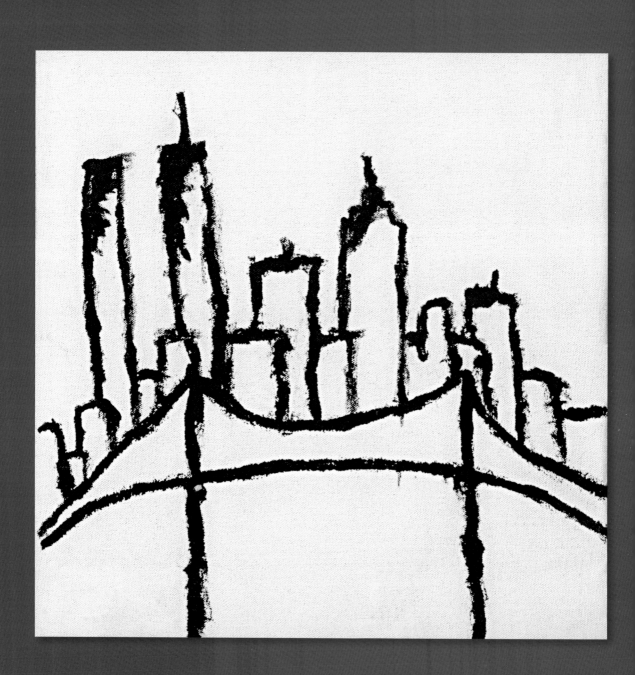

Art for Heart

My Aunt Lorraine

I miss my Aunt Lorraine
She's far, far away and one
day soon I will see her face
again.
Her pretty blue eyes that twink
like the stars.
One day she will look at me
and say come this way.
I miss my Aunt Lorraine very,
very much.
Her kind and loving, heart will
never break apart.
She loved her family so and
then God said you have to go.
We all cried that day when she
went away.
She always thougt of others
before herself.
Thats why she was so kind, loving
and caring.
I learned something that day when
my Aunt went away that God only
takes the best.

By. Megan Greene

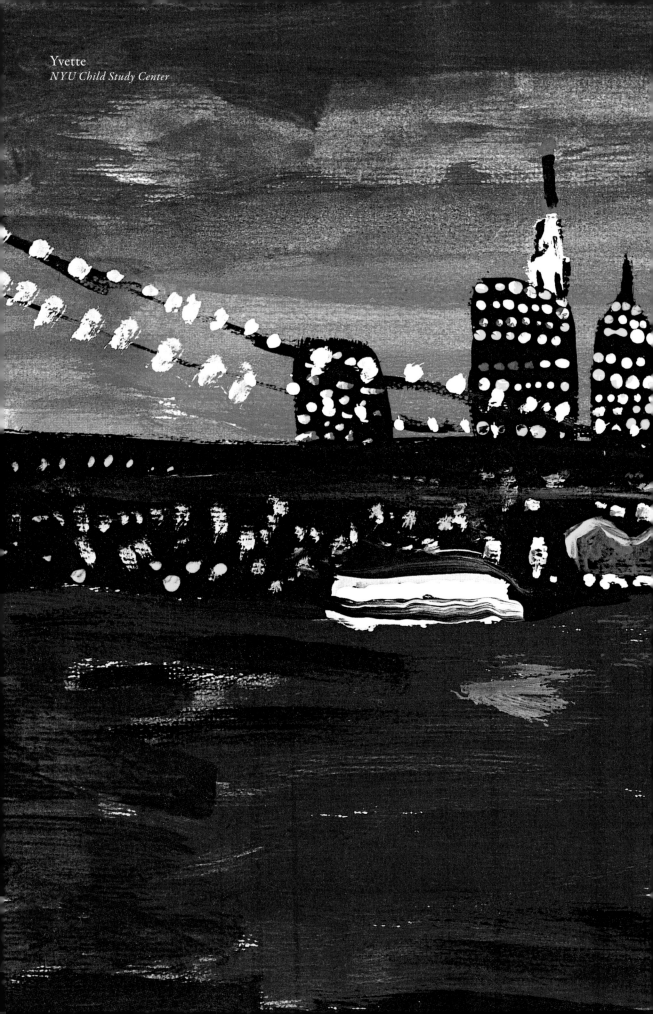

Yvette
NYU Child Study Center

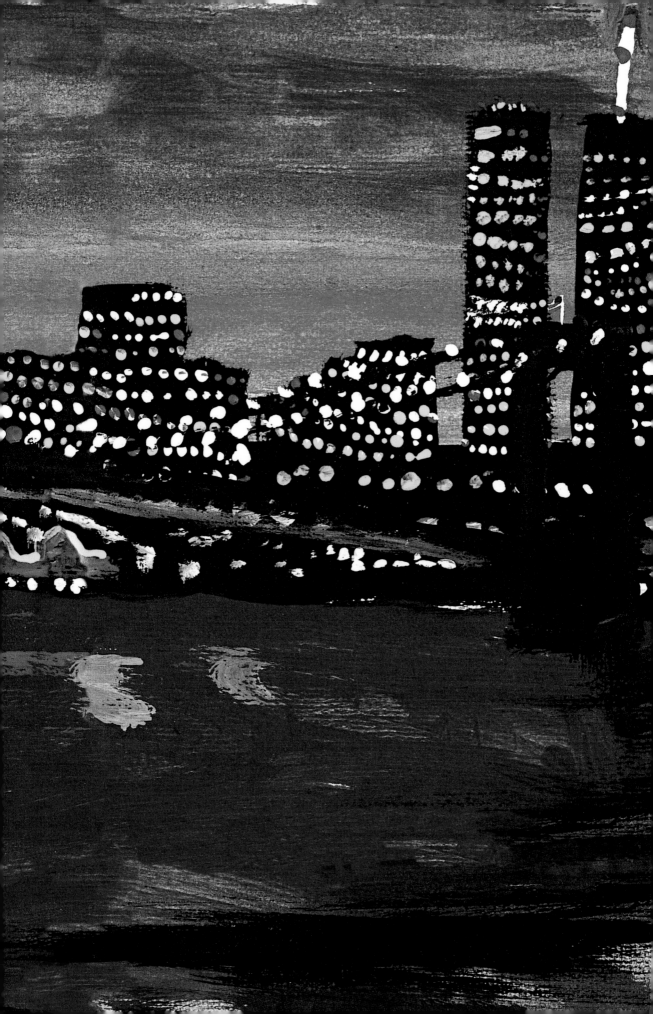

Paul Keim Dinosaurs rebuild twin towers.

Paul and Julian
NYU Child Study Center

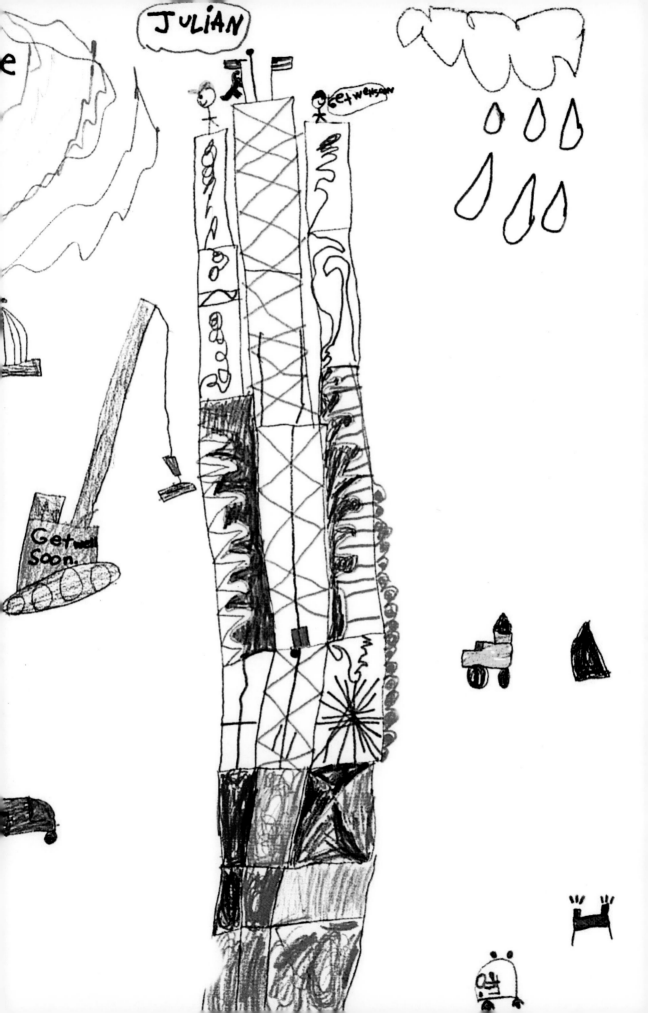

Art for Heart

I was in my 2nd grade classroom with my teacher Mrs. Jarding and everything stopped, and the tv's came on in our classroom, and Mrs. Jarding started to cry. Later that day we had a service at school.

Molly
Notes of Hope

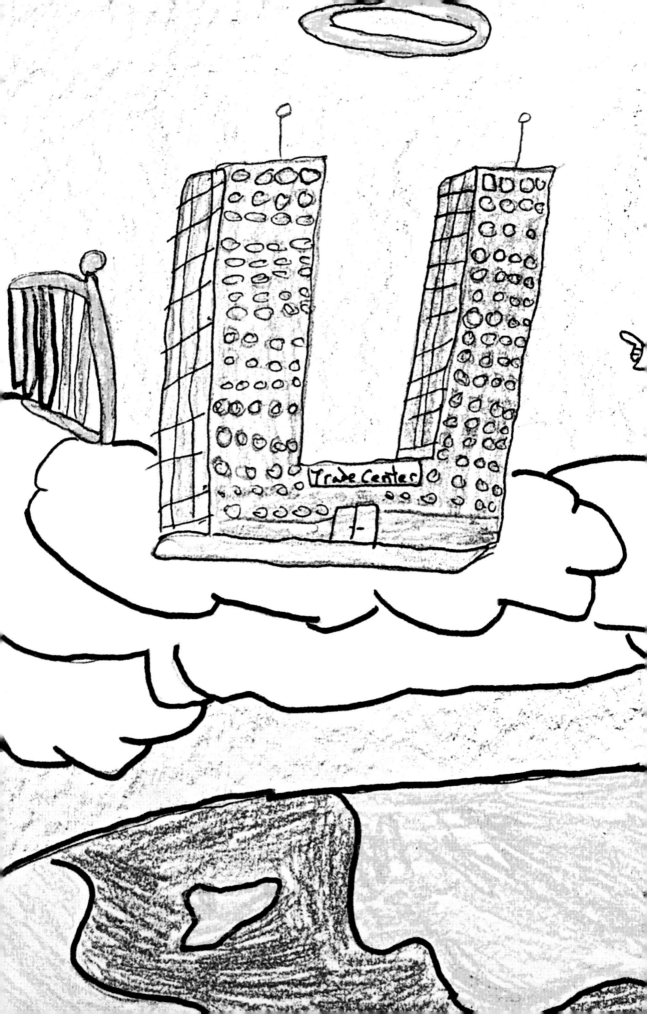

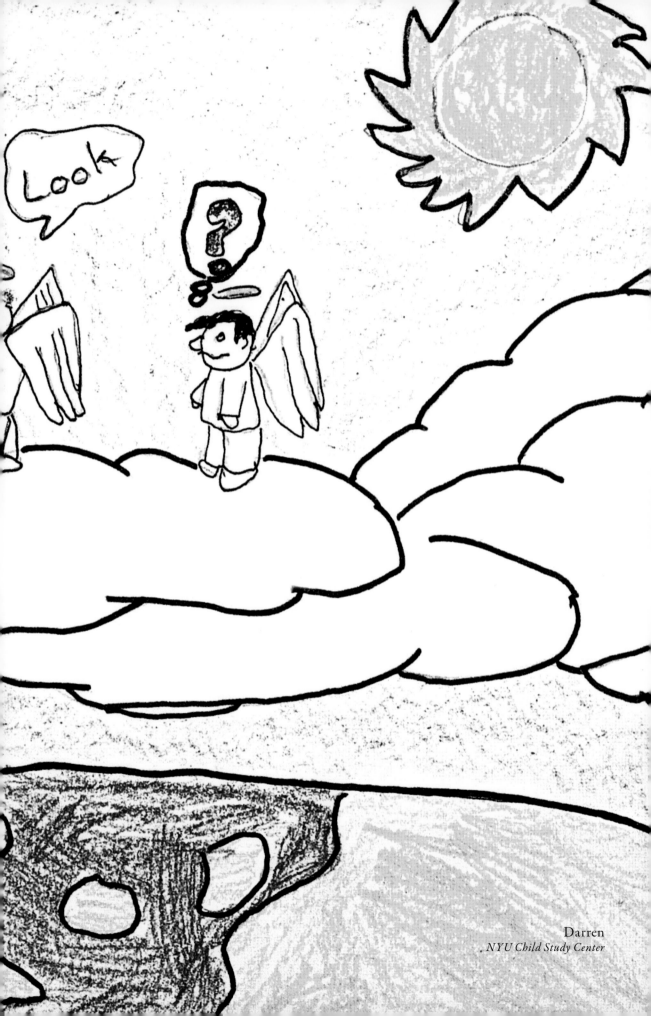

Darren
NYU Child Study Center

Art for Heart

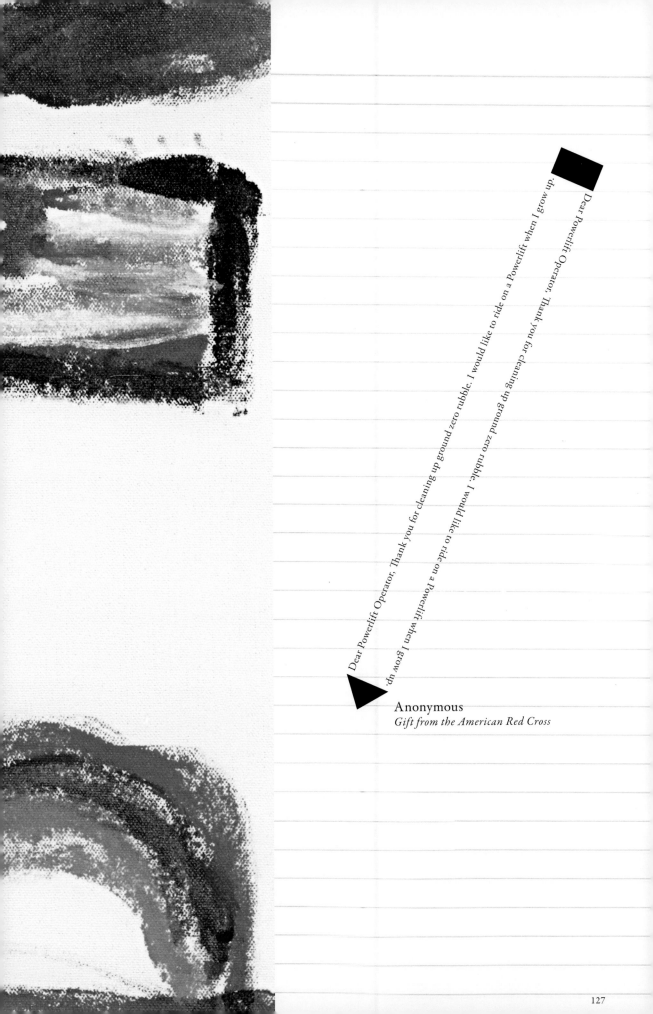

Dear Powerlift Operator, Thank you for cleaning up ground zero rubble. I would like to ride on a Powerlift when I grow up.

Dear Powerlift Operator, Thank you for cleaning up ground zero rubble. I would like to ride on a Powerlift when I grow up.

Anonymous
Gift from the American Red Cross

I'm thinking of you

✳

The firefighter represents all
the heroes of this event. His sadness
is shown by the title of his head …
The flag represents the nation's strength
as they overcome the tragedy.

Vivian
NYU Child Study Center

Dear Hero Collection, Gift of Tanya Hoggard

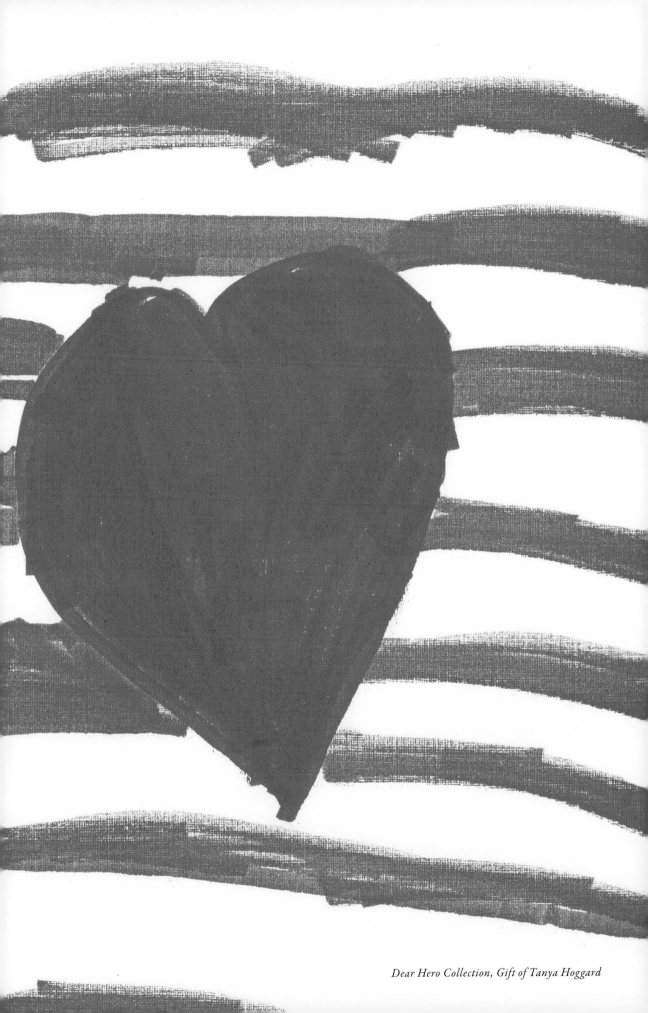

Dear Hero Collection, Gift of Tanya Hoggard

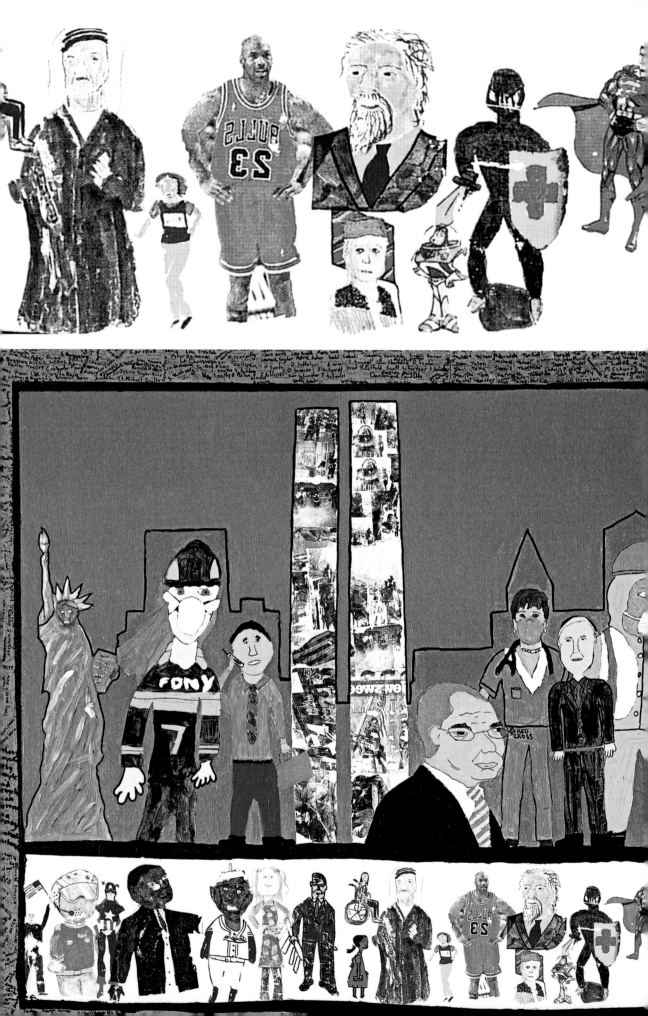

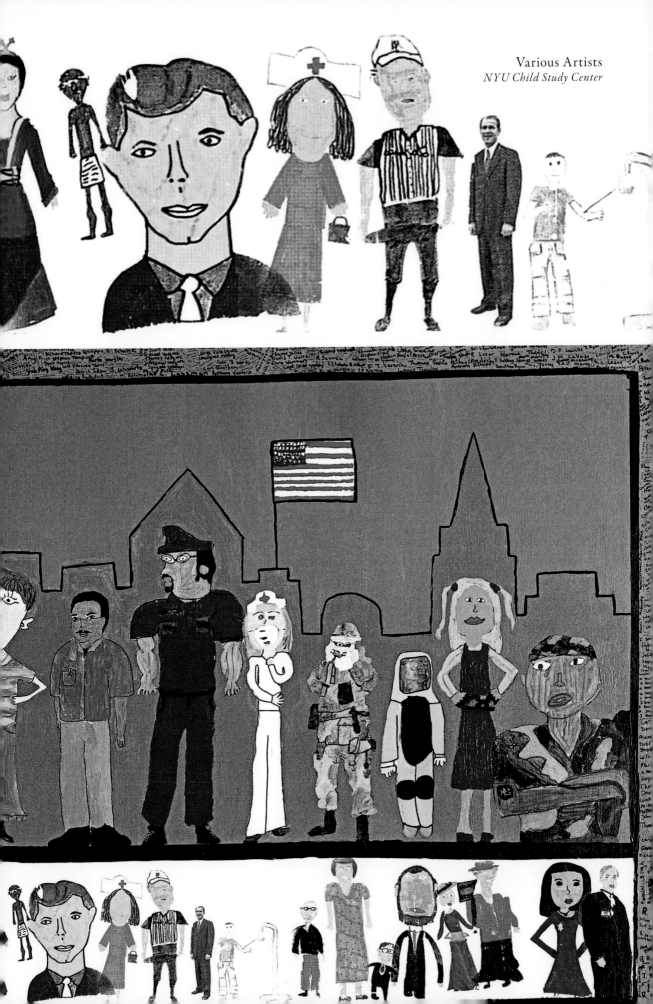

Art for Heart

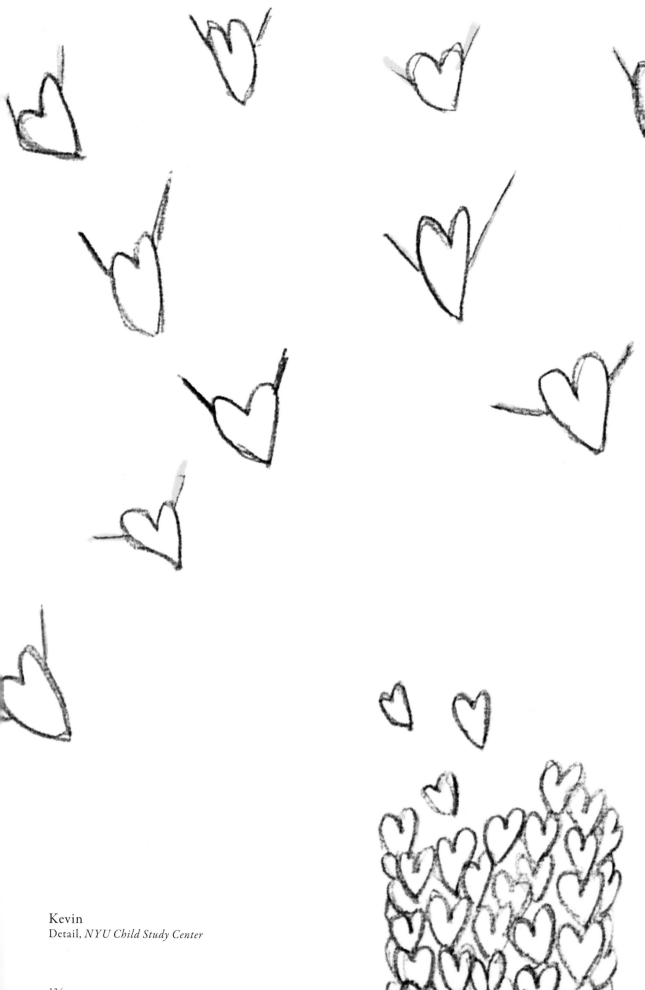

Kevin
Detail, *NYU Child Study Center*

I felt sad because the Twin Towers were my favorite towers.

To me, the Twin Towers were the face of New York.

Yvette
NYU Child Study Center

ACKNOWLEDGMENTS

The Milstein Family companies were one of the original contractors of the World Trade Center in 1972. Howard Milstein is currently CEO of Emigrant Bank and a board member of the National September 11 Memorial & Museum.

✳

The New York University Child Study Center is dedicated to increasing the awareness of child mental health issues and improving the research for the prevention, identification, and treatment of psychiatric disorders in children and adolescents on a national scale. In fall 2001, the center embarked on an ambitious project to study children's artwork triggered by 9/11, which culminated in a book by Robin F. Goodman and Andrea Henderson Fahnestock, titled *The Day Our World Changed* (Harry N. Abrams, Inc., 2002), and an exhibition that debuted at the Museum of the City of New York on the first anniversary of the attacks. We are grateful to the New York University Child Study Center for facilitating this important collection.

✳

The Art for Heart Program was initiated by the Lower Manhattan Development Corporation for children who lost a loved one in the February 26, 1993, or September 11, 2001, terrorist attacks. The program was developed to offer these children a way to express their emotions surrounding the attacks and the aftermath through art and to facilitate emotional healing. This program gave children an opportunity to personally contribute to a lasting memorial to their loved ones.

✳

This book also features selected images from the "Dear Hero" collection, compiled by Tanya Hoggard, a Delta Air Lines flight attendant. A volunteer at Ground Zero, she saw thousands of letters of encouragement and tribute sent to first responders and recovery workers, and has sought to preserve this outpouring of response. Tanya named the collection "Dear Hero," the greeting most often used by children in their notes and letters. She has donated the entire collection to the National September 11 Memorial & Museum, where selections will rotate on display. Cataloguing, preservation, and care of the "Dear Hero" collection in the museum's permanent collection have been made possible by support from Delta Air Lines.

✳

In September 2007, the National September 11 Memorial & Museum launched a national tour of steel beams from the World Trade Center site, which concluded in 2008. The beam signings and tribute events held in thirty cities and states generated a tremendous outpouring of heartfelt support. Thousands of people signed the beams with "Notes of Hope" and entered their names into history—helping to build this national monument.

✳

A special thanks to the Assouline Publishing team, including Prosper and Martine Assouline, designers Camille Dubois and Céline Bouchez, editorial director Esther Kremer, and editor Nicole Lanctot.